9 WEEKS TO
DISCOVERING,
BECOMING
& BEING

9 WEEKS TO DISCOVERING, BECOMING & BEING *You*

Dr. Tamara E. Wilson

Tandem Light Press
950 Herrington Rd.
Suite C128
Lawrenceville, GA 30044

Tandem Light Press paperback edition 2020

ISBN: 978-1-7341261-3-6
Library of Congress Control Number: 2019952320

Biblical passages are from New International Version. THE HOLY BIBLE, NEW INTERNATIONAL VERSION®, NIV® Copyright © 1973, 1978, 1984, 2011 by Biblica, Inc.® Used by permission. All rights reserved worldwide.

"We Wear the Mask," by Paul Laurence Dunbar is in the public domain. First published in *Majors and Minors,* 1896.

PRINTED IN THE UNITED STATES OF AMERICA

To my Sistah girls who helped me to trust, confide, be accountable, and know for sure the meaning of "I got you!" To each of you, I am forever grateful.

Contents

Foreword

Without question, I am blessed to write the foreword in this book for my mentee who I highly respect and hold sisterly love for, "Dr. Tammy."

The essence of Tammy's personality invites you on a journey where you will experience her passion, insight, and vision for Christian women. She is an innovative thinker who will awaken God's call in you and bridge the gap for sisters of all ages.

A cautionary word to the reader: put your seatbelt on as your experiences transform you into the woman you are meant to be. The mask will have to be removed so you can emerge into being your "best" self.

I count it an honor and a privilege to endorse a book that focuses on reinvigorating my passions after being a breast cancer survivor. During my treatment and after, I often questioned my purpose. I'm especially thankful because I was able to follow Dr. Tammy's teachings to a group of African American women, who, like me, are also breast cancer survivors. If you have ever asked yourself the question, *what is my purpose?* as you navigate the valleys, you will love this book. The inspirational messages will challenge you to be all that God intended for your life.

9 Weeks of Discovering, Becoming, and Being Me provides the tools needed to be your best self even if you are having a bad day. Each section sets a message of navigational destiny that will guide you into the very presence of God.

Reverend Doctor Tamara England Wilson has been in the secret place with God. Are you ready? This is it; an invitation to explore the *real* you as you experience rainy days and sunshine days.

- Rev. Dr. Ruth Travis, Retired Pastor in the African Methodist Episcopal Church,
CEO Ruth's Pink House

Introduction

For centuries, masquerade balls have been seen as an opportunity for people to come together for a fun-filled evening disguised in masks. Unfortunately, many people have mastered the idea of wearing a mask to conceal their true identity even when there is no masquerade ball to attend. While the mask conceals this true identity from others, at the same time, it prevents us from living authentically and being able to fulfill our God-given purpose.

9 Weeks to Discovering, Becoming & Being Me, was written to inspire you to live your best life authentically and on purpose. Written in a devotional style format for either group discussion or individual reflection, each week provides five daily inspirational readings, with thought provoking questions, a journal exercise, and a challenge to make a life changing commitment. This format is designed to empower you to examine your life in such a way that you are enabled to come from behind the masks and learn to be your best self.

Are you determined to pursue a life of purpose? Are you tired of pretending to be someone you are not? Then embark upon your own transformative journey of growth and change. Why not start today? One great thing about *9 Weeks to Discovering, Becoming & Being Me* is that you don't have to wait until the beginning of the week. Its format allows you to start right where you are, today. All you will need in addition to this book is a journal to write in and a commitment to being brutally honest with yourself. No matter what day it is, let today be the day that you begin your journey to discovering, becoming, and being the best you that you can be.

Part I

Discovering

Week One:
The Search for Fulfillment

Scripture Reading:

Blessed is the one
who does not walk in step with the wicked
or stand in the way that sinners take
or sit in the company of mockers,
but whose delight is in the law of the Lord,
and who meditates on his law day and night.
That person is like a tree planted by streams of water,
which yields its fruit in season
and whose leaf does not wither—
whatever they do prospers.

Psalm 1:1-3

Day One:
Coming Face to Face with Unhappiness

Blessed is the one
who does not walk in step with the wicked
or stand in the way that sinners take
or sit in the company of mockers,
but whose delight is in the law of the Lord,
and who meditates on his law day and night.
That person is like a tree planted by streams of water,
which yields its fruit in season
and whose leaf does not wither—
whatever they do prospers.

Psalm 1:1-3

Why begin a devotional book about discovering, becoming, and being who you really are with the subject of unhappiness? Surely this must be some sort of mistake. But it is not. For, unfortunately the very thing that brings us (women) to the point of declaring, "That's it! I am focusing on me!" is the fact that we are unhappy with our lives, as they are, in some way. Therefore, it is important that we begin with the subject of unhappiness.

No, you may not be walking around with tears in your eyes. You may not be wearing clothes that look like you took them straight out of the dirty clothes hamper. But just because your hair is done, your face is beat, your nails are done, and you are rocking the latest fashions complete with the baddest shoes, does not mean that you are happy. In fact, you could have it going on, a great job, a great man, great children, a great home, great friends and still be quite unhappy.

The reality is: women from all walks of life find themselves to be unhappy with their lives in some way. These women wake up one morning and ask themselves, *how did I get here? Here* is relative to the one asking the question and is often quite difficult to define. *Here* could mean in this relationship, in this job, or even in this situation. But no matter how it is defined, the question that is ultimately being asked is why am I where I am at this point in my life?

Just how one arrived here is just as difficult to pinpoint. It could have been a divorce, a bad breakup, or simply a bad relationship. It just as likely could have been the loss of a job, a missed opportunity, or a lack of finances. It really could be anything that causes you to realize where you currently are is not where you thought you would be. In other words, you desired to have reached some goal at some point and have found that you have not done so.

Realizing this, we begin to wrestle with questions such as, *why is this happening to me* and *why are things the way that they are in my life?* We begin to question our faith in God, believing that He is some way has abandoned us. Sometimes, we become susceptible to destructive behaviors: overeating, use of illicit drugs, excessive consumption of alcohol, unhealthy sexual behaviors, compulsive shopping, and the oh so dangerous behavior of comparing oneself or condition to that of others.

These things are all self-defeating. They lead you down the road of feeling sorry for yourself, which in some extreme cases leads to depression. Let's not go there; if you are already there let's do something to get you out of that mode.

The first step on the journey to discovering, becoming and being you is to acknowledge your unhappiness with where you are. Until you do so, you will be unable to commit to the journey.

For Reflection:

What am I expecting out of this journey at this point in my life?

Day Two:
The Source of Unhappiness

Blessed is the one
who does not walk in step with the wicked
or stand in the way that sinners take
or sit in the company of mockers,
but whose delight is in the law of the Lord,
and who meditates on his law day and night.
That person is like a tree planted by streams of water,
which yields its fruit in season
and whose leaf does not wither—
whatever they do prospers.

Psalm 1:1-3

By my junior year of college, I had already planned out my career in the field of speech and language pathology: I would attend graduate school immediately upon graduation, after which I would begin a very successful private practice which would attract clients from all over the state for speech and language therapy. However, I accepted a position as a speech-language pathologist in the local school district and within a few short years that dream had all but dissipated.

I was a pretty good therapist. My students were achieving their goals. Parents and staff called me a miracle worker. The hours were great, and the money was good. But I was terribly unhappy. Now don't get me wrong, no one was doing anything to me. The children were a joy—for the most part—and principals were requesting that I return each year. But there was something missing; I wanted more.

We all want more than what we have: more time, more money, more friends, more love. It is almost as if we are programmed to want more. Turn the television on at any given point of the day or night and you are inundated with things that feed our insatiable desire for more. You can get more car for your money and more value for the dollar. Just by watching certain programs you are told that you can get more knowledge, more understanding, and sometimes even more experience.

When your focus is always on getting more, where you are, what you have, and what you are doing will always fall short of making you happy. Do you recall being a child and saying, "I'll be happy when I grow up"? I believe we all said that.

We had all sorts of visions of what adulthood would bring—freedom from parents telling us what we could and could not do; the ability to choose for ourselves; being able to speak when we wanted, and to say what we wanted. This childhood idealism followed some of us into adulthood where we found ourselves saying things like, "I'll be happy

when I get married"; "I'll be happy when I get a new job or a better car." But the truth of the matter is, when and if those things occur, happiness still alludes us.

The bigger house does not make us happy. The new job does not make us happy. And even though we might fall madly in love with him when he comes, Mr. Right does not make us happy. Why? Because true happiness is not found in material possessions, in people, or any other external source. True happiness finds its source from within.

For Reflection:

What have I been pursuing, hoping it will make me happy?

Day Three:
In Pursuit of Happiness

Blessed is the one
who does not walk in step with the wicked
or stand in the way that sinners take
or sit in the company of mockers,
but whose delight is in the law of the Lord,
and who meditates on his law day and night.
That person is like a tree planted by streams of water,
which yields its fruit in season
and whose leaf does not wither—
whatever they do prospers.

Psalm 1:1-3

Blessed is the one who does not walk in step with the wicked or stand in the way that sinners take or sit in the company of mockers, but whose delight is in the law of the Lord, and who meditates on his law day and night. That person is like a tree planted by streams of water, which yields fruit in season and whose leaf does not wither—whatever they do is prosperous.

Psalm 1:1-3 describes a person who is blessed. Typically, when we use the word blessed, we mean to say that God has been good to us. It can range from the simple, "I am blessed!" to the more sophisticated, "I am blessed and highly favored." However, in this text, the word blessed is translated from the Hebrew word *ashar* which means happiness. This form of the word describes a person who is happy, fortunate, or deserving of some sort of congratulations. This person the psalmist compares to a tree.

Now, I absolutely love trees. For me they offer a sense of grounding, comfort, and tranquility. When I was a little girl, I would take a blanket and sit under a tree in the backyard to read. As a teenager, a chair replaced my blanket and I propped my feet up in the tree as I wrote in my journal. As an adult, simply observing a tree from the window of my home or as I ride in a car quiets my mind and settles my thoughts. But what makes the psalmist compare a tree to a person?

To understand this analogy, one must first understand that the tree the psalmist talks about is planted near a body of water. Being planted near water suggests that the tree is planted in moist soil that is deep and black in color, which further indicates that it is receiving all the nutrients it needs to support its development into a strong and healthy tree. For good soil allows for healthy downward root development which ensures a strong and solid foundation to support the upward growth of a solid trunk that produces branches that have vibrant and sometimes colorful leaves extending from them. This tree, according to the psalmist also produces fruit in its season.

Without a doubt this tree would be magnificent in appearance, a sight to behold, and certainly able to withstand any weather condition. Children would run to it to climb and hang upside down while picking its fruit. Lovers, hand in hand, would stand underneath, gazing into each other's eyes oblivious to the fruit. A mother bird would find safe shelter in it to nest and hatch her eggs among the fruit. This tree, planted near the water, yielding fruit, would attract so much attention because it is doing exactly what it was expected to do when it was planted there. It is being a tree.

A tree can be nothing more than what God intended it to be. It cannot be a blade of grass nor can it turn itself into a bird. No matter how hard it tries to become a human being, it cannot. It can only be a tree. The psalmist says the happy person, the fortunate person, the person deserving of congratulations is like that tree, they are being exactly who God created them to be.

Your happiness will never be found in the attainment of things nor will it be found simply in relationship with another. But true happiness that endures the ups and downs of life is found in being the person you were created by God to be.

For Reflection:

Are you like that tree planted by the rivers of water? Are you being who you were created to be or are you trying to be someone else?

Day Four:
A Necessary Shift

Blessed is the one
who does not walk in step with the wicked
or stand in the way that sinners take
or sit in the company of mockers,
but whose delight is in the law of the Lord,
and who meditates on his law day and night.
That person is like a tree planted by streams of water,
which yields its fruit in season
and whose leaf does not wither—
whatever they do prospers.

Psalm 1:1-3

The tree planted by the water which stands in full bloom with an abundance of good fruit hanging from its branches paints a wonderful picture of what it means to be happy. But for many of us to arrive at that place of happiness there must be a paradigm shift; a shift in our thinking as well as a shift in our behavior.

Where we once believed that being in a relationship would make us happy, a paradigm shift helps us to see that this belief is far from reality. Where we have placed our confidence in our ability to create wealth to bring us happiness, a paradigm shift helps us to see that these things will only lead to disappointment. Where we once sought happiness in the acquisition of things and/or power, a paradigm shift helps us to see that pursuit as misguided.

Making this shift in our thinking is critical if we ever hope to be truly happy. Until it is made, we continue to the cycle of replacing one thing for another in pursuit of happiness. We will be happy once the older model car is replaced with a newer and more updated one. We will be happy when the old, worn out, or outdated wardrobe is replaced with a newer more fashionable one. We will be happy when we can find a better job, with better pay, to replace this boring one. Continuing on this way only guarantees that one day, maybe not today, tomorrow or even the next day, waking up with that sinking feeling that I am not where I want to be.

This question almost always leads to the search for more—more of this or more of that. For inevitably the person who pursues happiness from external sources finds that happiness always is just beyond their reach. With the attainment of one thing something else is always missing.

I contend what that person is missing is herself. The person she was meant to be is what is missing. When a woman is willing and able to make the shift in her thinking

concerning the source of true happiness, she will be able to declare, if only to herself, I am what is missing in my life.

The tree planted by the water will never be able to bear good fruit, whether it is figs, apples, or pears, if it is off somewhere trying to be a light pole. In order for the tree to bear good fruit it has to be what it was meant to be—a tree. Likewise, in order for you and I to be happy we must begin at ground zero: being the person God meant for us to be.

Many women go through life and never get the opportunity to be who they were really meant to be. While they may have many wonderful experiences and accomplish many outstanding things, they will never know what they could have accomplished if they were being who they were truly created to be. What a loss to themselves and to humanity.

For Reflection:

Have I denied myself the opportunity to just be myself?

Day Five:
Unique in My Own Way

Blessed is the one
who does not walk in step with the wicked
or stand in the way that sinners take
or sit in the company of mockers,
but whose delight is in the law of the Lord,
and who meditates on his law day and night.
That person is like a tree planted by streams of water,
which yields its fruit in season
and whose leaf does not wither—
whatever they do prospers.

Psalm 1:1-3

When I was a young girl, I dreamed of being a famous singer. In my bedroom wearing a turtleneck as a wig and using a hairbrush as a microphone I performed the latest hits. My fear that others would think that I was not good enough kept my dream hidden behind closed doors. If only I knew then what I know now, perhaps I would have pursued that dream. Perhaps I would have filled concert halls with admiring fans. Perhaps they would have screamed my name and fainted when they saw me. Perhaps I would have been a one hit wonder or maybe it was only a childhood fantasy. The world will never know.

But I do know that being who I am is not time sensitive. Who I am is who I am. You never truly miss the opportunity to be who you really are if there is still breath that remains in you. The reality is, if there was still something within me that desired to sing, I could still pursue that dream. But, today I have no desire to perform for the masses. I am content with spontaneous performances during family events and the occasional spirit-led selection at church. The point is that it is never too late to begin to do what is an expression of who I am as a person.

The problem is many women wake up one day and discover that they are living lives and doing things that are not truly an expression of who they are. Unfortunately, some never do anything about it. They concede to the "it's too late to do anything about it mindset" or the "what will everybody else think" mindset.

There are not too many things sadder than waking up to the realization that you have not been living your life, but you have been living the life that your parents, your college professor, or someone else imposed on you through their hopes, thoughts, dreams, or desires. This is in no way to say that these impositions were negative. Some people are living wonderfully fulfilled lives and are experiencing wonderful things as a result of following the path others guided them towards. But there are those who are living lives

that are less than fulfilling and perhaps are missing out on wonderful experiences all because they are not being true to who they really are.

Our Scripture this week makes it absolutely clear that happiness is a result of being and doing as we were created to be and do. What we do is an expression of who we are and it is revealed in different ways, even if we are doing the exact same thing. Why? Because we are all unique in our own way. When we tap into the uniqueness of who we are then we discover the happiness we so desire. Anything else leads to a superficial form of happiness that soon withers away.

For Reflection:

Have I allowed the hopes, dreams, or thoughts of others to dictate the direction of my life?

Day Six:
Journal Day

Blessed is the one
who does not walk in step with the wicked
or stand in the way that sinners take
or sit in the company of mockers,
but whose delight is in the law of the Lord,
and who meditates on his law day and night.
That person is like a tree planted by streams of water,
which yields its fruit in season
and whose leaf does not wither—
whatever they do prospers.

Psalm 1:1-3

Journaling gives insight into you. Sometimes, it will be the medicine needed to release emotions that have been pent up, other times, it will help you better get to know you. Still, at other times it will help you deal with a particular problem. Additionally, journaling will help you to see how God has been guiding you through the years. Each week you will be asked to review your answers to the reflection questions provided after each reading. Then you will be given a short journal exercise.

For today, reflect on this week's scripture and the answers you provided to the reflection questions that follow each reading. Then journal about what you have learned about yourself this week. What are your thoughts about happiness now?

Day Seven:
Commitment Day

Blessed is the one
who does not walk in step with the wicked
or stand in the way that sinners take
or sit in the company of mockers,
but whose delight is in the law of the Lord,
and who meditates on his law day and night.
That person is like a tree planted by streams of water,
which yields its fruit in season
and whose leaf does not wither—
whatever they do prospers.

Psalm 1:1-3

Each of us has the potential to fulfill whatever we put our minds to. You will be asked to begin each week making a commitment to yourself to implement some aspect of what you gleaned from the week's readings and your journaling. Write your commitment on an index card and carry it with you as a constant reminder throughout the 9 weeks.

Begin this next week with the commitment to view happiness differently. See the example below then write your intention on an index card and carry it with you as a reminder of your commitment.

_____ is not the source of my happiness. Therefore, changing _____ will not make me happy.

Week Two:
 Where I am

Scripture Reading:

Then you will know the truth, and the truth will set you free.

John 8:32

Day One:
I am Doing this Because...?

Then you will know the truth, and the truth will set you free.

John 8:32

When I was a young girl my mother used to bake the best homemade rolls in the world. She would start by putting the ingredients in a big bowl which she would knead with her hands until a small mound of dough formed. She would then cover the bowl with a dishtowel and place it on top of the refrigerator where it would sit for hours.

Throughout the day she would take the bowl down, remove the dishtowel, and knead the dough for a few minutes. Then she would replace the dishtowel and return the bowl back on top of the refrigerator. Hours later when the small mound of dough had filled the bowl, she would lay it out on a flour covered table, then using a wooden rolling pin she would press the dough flat. Following this, she used a drinking glass to cut little round circles out of the dough. These she placed in a pan then in the oven. They really were the best rolls.

One day while at my grandmother's house, I went into the refrigerator for something to drink and she yelled out something about making her rolls fall. I looked up and to my surprise she had a bowl on top of her refrigerator covered with a dishtowel. I discovered that my mother had learned to make her delicious rolls from her mother. So, I decided when I became a mother that I, too, would do the same thing.

I could not wait to share this experience with my daughters. I could not wait to knead the dough and place the covered bowl on top of the refrigerator. I knew my girls would think that my rolls were the best in the world. So, when the time was right, together we went to the grocery store to get the ingredients we needed to bake homemade rolls just as Granny and Mama use to make when I was a girl. However, we walked out of the store with two cans of Pillsbury Buttermilk Biscuits.

Sometime later, determined to share the homemade roll experience with my girls we went to the grocery store to purchase the necessary ingredients to make homemade rolls. We left that time with a package of brown and serve rolls. The idea hit me once more, when the girls were a little older. This time I went to the grocery store alone. For surely, it had been their fault that we did not get the ingredients we needed to make the homemade rolls I grew up enjoying.

Sure enough, I left the store with every ingredient the recipe called for. I went home and placed the ingredients in the cabinet where they sat for years. I just never seemed to feel like making homemade rolls. Kneading dough and waiting hours for it to rise on top of the refrigerator, while it seemed like a great idea it was not for me.

It has taken me some time to fully embrace this concept; but just because someone else enjoys something does not necessarily mean that it will be enjoyable to me. The

world will not come to an end simply because I do not make homemade rolls. Nor will it come to an end because I decide not to do something that has always been done. We as women must learn to embrace what we enjoy because what we enjoy is key to discovering who we really are.

For Reflection:

What are the things you have told yourself you need to do or be in order to be acceptable as a good mother, good wife, etc.?

Day Two:
An Expression of Whom?

Then you will know the truth, and the truth will set
you free.

John 8:32

I am always intrigued by how people introduce themselves when asked to do so in a group of strangers. Most people simply talk about what they do or who they are in relation to other people. For example, they will tell you their name, where they work, and what they do. Some will even tell you whether or not they are married and if they have children. When pressed to say more, most will simply look toward the ceiling and declare with a smug look on their face that they don't know what else to say.

While this really could be a matter of not being comfortable speaking about oneself in public, I believe it is more likely the result of an uncertainty of who we are beyond those surface things. Certainly, our experiences, what we do, our relationships, and what we believe are influenced by who we are, but those are not things that should define who we are.

We each come into the world as an empty canvas, full of potential and limitless possibilities of how we can express who we are. However, before we ever have the opportunity to do so someone else has painted their hopes and dreams on our canvas. Typically, the first to apply paint to our canvas are our parents. If you were blessed with good parents their intent was to paint beautiful things on your canvas ensuring that you felt their love, acceptance, and support. All the things that help us to be the very best we can be.

Besides parents, there are siblings and other extended family members, teachers, friends, and even strangers who add paint to the canvases of our lives. Sometimes the paint they add enhances the canvas and sometimes, unfortunately, even with the best of intentions, they paint things that mar the canvas and leave us feeling unloved, unaccepted, and unsupported.

Every paint stroke is an experience that either adds something good or adds something bad to the canvas. Each stroke of paint on the canvas impacts our ability to be who we really are. But the picture that is revealed on the canvas is not always an accurate indication of who we really are. Sometimes the paint has created an image of someone whose life we take on, while the true person remains hidden.

Allowing paint strokes or experiences to define you limits your ability to fully express the person you really are. In other words, who you become will be limited to what you were told, how you were treated, and what was or is acceptable. Unfortunately, when and if those experiences, relationships, or beliefs no longer hold significant value to you, you will begin to lose the identity you have come to embrace.

For Reflection:

Have I become an
expression of what
others think I should be?

Day Three:
Owning Up to the Truth

Then you will know the truth, and the truth will set
you free.

John 8:32

In the Shakespearean play that bears his name, Hamlet asked the question, "to be or not to be" as he contemplates whether "'tis noble to suffer life or to end one's suffering." This quandary that Hamlet found himself in is similar to what many women face when they consider whether or not to be true to who they really are. Faced with the anxiety of what others may think or how they may be treated, many find it much easier to simply continue to hide who they are.

Authenticity, we all claim to desire it, yet we often go out of our way to avoid it. Take offering your opinion on an issue, for example, it does not matter the subject—race, religion, or politics—voice it to the wrong person and it may land you in a world of trouble. Therefore, we weigh the cost of being honest in what we say. The same is true when it comes to being authentic in who we are as a person. We desire authenticity, but it comes at a very high price. For in order to be authentic, we must deny or confront deception.

Deception is a tool of confusion and sometimes fear. It can be used to gain control over others by causing them to believe something that is not true. Deception is potentially harmful to the person being deceived and is very hard to fight against because the one being deceived is unaware of what is really going on. Deception is extremely dangerous when the one being deceived is also the deceiver. This is, in essence, when we deceive ourselves.

Really, it happens. In the fifty-eighth chapter of Isaiah, the Israelites were suffering under hard economic conditions, so they sought God's deliverance as they always had through fasting and praying. But unlike other times, God did not come to their rescue. Israel was baffled and could not understand because they were doing so that God would deliver them; they fasted and prayed.

But, God told Isaiah, the prophet, to cry aloud, to lift up his voice like a trumpet, so that all the people could hear that He was paying no attention to their fasting and praying because they were simply going through the motions. Outwardly, they appeared devoted to God, but they were not sincere in their actions. Their fasting and praying meant absolutely nothing to them. They had deceived themselves into believing that they could deceive God with outward appearances of devotion.

Just as the Israelites had to take a hard look at themselves and admit that they were not being authentic to who they were as a people, we must also take a hard look at ourselves and admit if we are not being authentic to who we really are. Trying to fit in, attempting to abide by societal expectations and traditions is nothing more than an attempt to deceive. These things will never lead you to authenticity. They will only lead to a spiraling downward path of deception.

For Reflection:

Am I deceiving myself
into believing that the
me that I am displaying
is the me that I really am?

Day Four:
Is This Really Me?

Then you will know the truth, and the truth will set you free.

John 8:32

The Disney movie Mulan tells the story of Fa Mulan, a young woman who struggles with the traditional values of what it means to be the perfect daughter. Mulan struggles trying to conform to expectations—learning to walk, dress, and act a certain way—in order to one day bring her family honor, despite her own desire to be a warrior as her father had been.

Dutifully, she participates in the ritual of preparing to meet the matchmaker to determine her eligibility of being a good wife capable of bearing sons for her husband. However, after some hilariously funny unfortunate events, the meeting ends with the matchmaker declaring Mulan a disgrace who would never bring honor to her family. The movie continues detailing Mulan's internal struggle of being true to who she really was in a society where it would never be allowed. But this becomes a reality for Mulan when she secretly decides to enlist in the Chinese army as a man.

This struggle of acceptance and being true to self is played out in the lives of many women. Fitting into the molds of others is commonplace. Doing what others think is best is often quite natural. Being accepted and gaining approval is important. All of our lives people have been telling us what we should do or shouldn't do. Their words, their ideals, their acknowledgments, their expectations become the basis for our actions and sometimes our inaction, which impact on who we become.

Though you may accomplish much, accomplishment does not always indicate authenticity. Success does not always mean that you are doing what you had really hoped to do. Therefore, it is important to figure out who you really are without attempting to measure up to standards imposed by others.

Like a prisoner who sits behind the steel bars of the penal system, when you conform to the desires of outside forces, your authentic self is held captive and longs to be free. Your authentic self longs to live a life uninhibited and unconfined. Your authentic self longs to express herself exactly the way God decided when He was fashioning you in your mother's womb. Your authentic self wants what we all want, an opportunity, another shot, another chance to soar and become the person she was meant to be. In order for these things to take place, you must determine your level of inauthenticity.

For Reflection:

Am I being me?

Day Five:

Then you will know the truth, and the truth will set you free.

John 8:32

In one of my all-time favorite Disney movies, *The Lion King*, Mufasa, the lion king is tragically murdered and his young son, Simba, the heir to the throne, is forced to leave the Pride Lands. Scar, Mufasa's evil brother assumes the throne, ruling in a way that brings destruction and lack to the once prosperous land. Simba, though living in exile, settles into living the life of leisure without a care in the world, eating bugs and singing in the jungle with his newfound friends.

One day he runs into his childhood friend, Nala, fleeing the Pride Lands. She informs him of Scar's rule and the widespread destruction and encourages him to return there immediately to take his rightful place as king. But Simba, content with living by the mantra, "Hakuna Matata", refuses. That is until he meets Rafiki, the baboon.

Rafiki, is ever so wise and he leads Simba to the river to see Mufasa. Once there, Simba hears Mufasa say from the clouds, "You have forgotten who you are... Look inside yourself, Simba. You are more than what you have become. You must take your place in the Circle of Life." These words serve as an epiphany for Simba awakening him to the reality that he was not born to lie in fields of grass to ponder the meaning of cloud forms. But, he was meant for so much more.

If by chance, you were to see your reflection in the river what would it say to you? Perhaps you, like so many others, would hear the same words that Simba heard, "You are more than what you have become." Would you agree?

Are you more than what you have become? Recognizing that we are all a work in progress, are you on the path that you were meant to be on that leads to the place you were meant to be? Perhaps, like Mulan, there is something that you truly desire to do that you have concealed deep down in fear of humiliation and scorn. Perhaps you are like Simba and are avoiding being authentic to who you really are. Or perhaps, there is something unknown calling out from within nudging you to set it free.

Whatever it is, it is my hope that the words of Mufasa will lead you beyond just a need for more schooling, a larger house, or more income. But may Mufasa's words, as they did with Simba, get to the heart of any inauthenticity that you have learned and adapted to in order to seek acceptance from others. And may this realization ignite a desire within you to discover or rediscover who you are and your unique contribution to the world.

For Reflection:

What words would you hear if you looked into the river at your reflection?

Day Six:
Journal Day

Then you will know the truth, and the truth will set
you free.

John 8:32

Take time today to listen to the song "Reflections" from the movie Mulan. Consider
the words as you reflect on this week's scripture and the answers you provided to the
reflection questions that follow each reading. Then capture your thoughts in your journal.

Look at me,
I may never pass for a perfect
bride, or a perfect daughter.

Can it be,
I'm not meant to play this part?

Day Seven:
Commitment Day

Then you will know the truth, and the truth will set you free.

John 8:32

Begin this next week with a commitment to seeing beyond the reflection so that you can discover the woman you who lives within. Write this commitment on an index card that you carry with you this week as a constant reminder that you are more than you have become.

Week Three:
What Does God Say?

Scripture Reading:

I praise you because I am fearfully and wonderfully made;
your works are wonderful,
I know that full well.
My frame was not hidden from you
when I was made in the secret place,
when I was woven together in the depths of the earth.

Psalm 139:14-15

Day One:
I am a Work of Art

I praise you because I am fearfully and wonderfully made;

your works are wonderful,

I know that full well.

My frame was not hidden from you

when I was made in the secret place,

when I was woven together in the depths of the earth.

Psalm 139:14-15

Psalm 139:14-15 is considered to be one of the most beloved psalms in all of scripture. Believed to be written at a time when he was being persecuted by Saul, David—overshadowed by the fact that he was innocent of any wrongdoing—comforts himself reflecting on the fact that God was all knowing, and alone knew his heart. Lost in this truth, David further considers that God is almighty in power for He was the One who had created him.

David didn't buy into the scientific theory that there was a Big Bang and suddenly man appeared. He hadn't been duped into believing that he was a descendant of an ape. He didn't even rest in his understanding of a man and a woman coming together. But he marveled over the fact that his birth was a direct result of the will and miraculous work of an omnipotent God. This reflection was in and of itself quite overwhelming, so much so that David could no longer contain himself, and as an expression of his gratitude He declared unto God, I praise you because I am fearfully and wonderfully made.

David got caught up. He understood that God had formed him while he was in his mother's womb; created his innermost parts, the things that allowed him to think, move, and respond as he had, because God was preparing him to be king. David believed that what Saul envied was the work of the very skillful hands of an omnipotent God.

The same applies to you and me, when God created you, He created a work of art, a masterpiece. He put some thought into what He was doing. He molded and shaped you according to His will, according to His specific plan for your life. He knew what you needed in order to do what He had in mind for you, so He put all the right stuff in you. Don't get it twisted: God does everything with a specific purpose in mind.

You were fearfully and wonderfully made, the work of an omnipotent, all powerful God for a specific purpose that He had in mind from the beginning for you to do. From the moment that He decided to create you He had a plan for your life. Despite what you may have been told or what your self-esteem allows you to believe, God has a specific plan for your life. You weren't born to conform to whatever your circumstances or

experiences allow. No, when God created you, He did so to use you to fulfill His purpose here on the earth. That's just the way He works!

Unfortunately, many of us allow the circumstances that we face cause us to run away and hide from who we really are. Instead of holding on to the reality of being fearful and wonderfully made, we adjust who we are to accommodate our circumstances. Then, slowly, over time we become less and less the person God created us to be. This is no way for the fearfully and wonderfully made to live.

For Reflection:

What thoughts come to mind when you consider that to God you are a work of art?

Day Two:
He Had a Plan in Mind for Me

I praise you because I am fearfully and wonderfully
made;

your works are wonderful,

I know that full well.

My frame was not hidden from you

when I was made in the secret place,

when I was woven together in the depths of the earth.

Psalm 139:14-15

God is sovereign and as Creator of humanity He reserves the right to do as He pleases with that which He creates. In other words, God does not need your permission or mine, nor does He need to provide an explanation for the way He created you. For when He created you He did so with purpose in mind. This God illustrates in Jeremiah 18:1-10 when He sends the prophet Jeremiah to observe the potter at work at the potter's wheel.

God sent Jeremiah to observe the potter working with clay at the potter's wheel. The potter was working the clay into a pot when for some reason the pot became marred then without missing a beat the potter became to rework it into a new pot that seemed best for him. What is important for us to see is that the potter is the one who determines what he would create at the wheel. Before he started working at the wheel, he knew what he would make. The clay, in contrast, was not consulted, nor was it involved in the decision-making process. The decision was made solely by the potter, the creator of the pot.

Before we were born, God knew who He desired for us to be. Before He placed us in our mother's womb, He had a reason for our existence. So, He molded and shaped each of us according to what He had in mind for us. There is nothing about us that is an accident or coincidental. It is all by design of a wonder-working God.

What God had in mind for you is not necessarily the same thing He has in mind for me. What He has in mind for you may not necessarily be to my liking and vice versa. But that is neither here nor there; we were each shaped by God into the person He desired us to be, in the way that seemed best to Him and Him alone. How He created you may not be to your liking, but that, too, is of no consequence. God, like the potter at the wheel, is the one who one who does the shaping and molding.

Many of us spend too much time wishing we were different being jealous or envious of others. We spend too much time comparing ourselves to others wondering why they have something that we don't have. The answer to that is simple: God determined it to be just as it is. While I would love to be able to act the way Viola

Davis does or play tennis the way Serena Williams does that is not what God had in mind for me.

What God had in mind for me is what He shaped me for when He created me. It is up to me to discover just what that is. How unfortunate it is to go through life unaware of what God's purpose for your life is. How unfortunate it is to live aimlessly following the path charted by others. How unfortunate to live life in competition with others. God's best awaits you as you discover what He purposed for you from the beginning.

For Reflection:

Do you have an idea of God's purpose for creating you?

Day Three:
There Are Expectations

I praise you because I am fearfully and wonderfully
made;

your works are wonderful,

I know that full well.

My frame was not hidden from you

when I was made in the secret place,

when I was woven together in the depths of the earth.

Psalm 139:14-15

In Luke 13:6-18, Jesus shares a parable about a fig tree that is planted in the middle of a vineyard. One day the owner of the vineyard comes to check on the condition of his vineyard and notices that the fig tree that he had planted there had not produced any figs in three consecutive years. Since it had not done what it had been planted to do the owner decided to have it chopped down. Jesus' point was like the fig tree, one day we, too, would be judged for what we have done with our lives.

While we all desire for our lives to have meaning, unfortunately many of us are content with living life as we chose doing the things we desire to do, the way we desire to do them. I do not mean to suggest that we are not being productive or that we are not successful at what we have chosen. But what I am suggesting is that many of us are content with something other than what God desires for us to do, or worse, some are content with simply existing in the world.

It is not okay to God when His children are content with living the status quo or simply existing to live. It simply is not enough serving in one capacity one day and another the next. It is not enough to live to impress others or to compete with others. What God expects is that you do whatever it is that He put you here to do. To do anything less is to be like that fig tree in the parable, unproductive.

The Apostle Paul explains it this way in Ephesians 2:10: "…we are God's handiwork, created in Christ Jesus to do good works, which God prepared in advance for us to do." What Paul was saying was, when God redeemed us from sin, through Jesus' work on the cross, He not only delivered us, but He also made us new in Christ. He made us a new creation, so that we might do what He had prepared from the beginning for us to do. That specific work He created us for in order to bring Him glory.

We must each ask ourselves, *for what reason I been given life?* We were not born to roam aimlessly about the earth pursuing any and everything that happens to cross our path. We were meant to pursue the purpose God had in mind for us when He created us. It is in the pursuit of His purpose for us that we find meaning and fulfillment. It is this pursuit in life that we find the happiness we so desire.

For Reflection:

Have you any idea what God's purpose for you is?

Day Four:
Accountability

I praise you because I am fearfully and wonderfully
made;

your works are wonderful,

I know that full well.

My frame was not hidden from you

when I was made in the secret place,

when I was woven together in the depths of the earth.

Psalm 139:14-15

In Matthew 25:14-28 Jesus shares the parable of the talents. The scene was fairly common in Jesus' day; wealthy people took long trips and given the uncertainty of the time of their return they left their servants in charge of their wealth. Although this money was entrusted to them, it still belonged to the master, but the servants were to manage it until the master returned.

This is what the master in the parable does before leaving for his trip. Three of his servants were given a different amount to manage: five talents, two talents, and one talent. A talent, equal to one day's pay, in today's money the servants would have been received $500,000, $1 million, and $2.5 million. So you see what they were given was very valuable and indicated the master's trust in their ability to manage the money.

Just as a substantial amount of money was entrusted to the servants in the parable, we have been given gifts by God. These gifts, whatever they are and whatever the number we have been given, are not ours, they belong to the Lord. They have simply been entrusted. In other words, God expects us to use the gifts He has given us. These gifts were given according to His will and as none of the servants in the parable were given more than they were capable of handling; we too, are not given any gift that we cannot handle.

When it comes to using the gifts, we have been given many times we ignore the ones we have been given and covet the ones given to another. Think I'm wrong? How many times have you imagined yourself winning the Wimbledon or on stage performing before a sold-out crowd at a concert hall? Me? More times than I can count. But we were given the gifts that we have by God because those are the gifts we were equipped by Him to excel at. We have no right to sit and complain about what God has or has not given us. He knows exactly what we can handle.

How do you feel when you give someone a gift? Don't you expect for them to use it? Would you be bothered if they took the gift you gave them and threw it in the closet? I'm sure you would expect for them to use what you gave them.

In the same way, God, like the master in the parable, has the expectation that what He has given would be put to use. While we are not told how to use them, the expectation is that we would use them with enthusiasm and a sense of urgency to the fullest of our ability. For one day, like those in the parable, our Master will one day expect an accounting of what we have been given.

For Reflection:

Read Matthew 25:14-28 included below for yourself and determine which of the servants you are most like — the first two or the third?

The Parable of the Bags of Gold

"Again, it will be like a man going on a journey, who called his servants and entrusted his wealth to them. To one he gave five bags of gold, to another two bags, and to another one bag,[1] each according to his ability. Then he went on his journey. The man who had received five bags of gold went at once and put his money to work and gained five bags more. So also, the one with two bags of gold gained two more. But the man who had received one bag went off, dug a hole in the ground and hid his master's money.

"After a long time the master of those servants returned and settled accounts with them. The man who had received five bags of gold brought the other five. 'Master,' he said, 'you entrusted me with five bags of gold. See, I have gained five more.'

"His master replied, 'Well done, good and faithful servant! You have been faithful with a few things; I will put you in charge of many things. Come and share your master's happiness!'

"The man with two bags of gold also came. 'Master,' he said, 'you entrusted me with two bags of gold; see, I have gained two more.'

"His master replied, 'Well done, good and faithful servant! You have been faithful with a few things; I will put you in charge of many things. Come and share your master's happiness!'

"Then the man who had received one bag of gold came. 'Master,' he said, 'I knew that you are a hard man, harvesting where you have not sown and gathering where you have not scattered seed. So I was afraid and went out and hid your gold in the ground. See, here is what belongs to you.'

"His master replied, 'You wicked, lazy servant! So you knew that I harvest where I have not sown and gather where I have not scattered seed? Well then, you should have put my money on deposit with the bankers, so that when I returned I would have received it back with interest.

"'So take the bag of gold from him and give it to the one who has ten bags.

[1] Matthew 25:15 Greek *five talents ... two talents ... one talent*; also throughout this parable; a talent was worth about 20 years of a day laborer's wage.

Day Five:
He Holds You in His Hands

I praise you because I am fearfully and wonderfully made;
your works are wonderful,
I know that full well.
My frame was not hidden from you
when I was made in the secret place,
when I was woven together in the depths of the earth.

Psalm 139:14-15

There are times when we go through difficult situations and circumstances in life and we begin to struggle with the meaning of it. We know that God says He has a plan for us yet with all the hell that is breaking loose around us that seems more of a fallacy than a reality. Then there are those times when despite how hard we try, we do things that are to our own detriment and downfall and we begin to feel like God is a million miles away, distant and somewhat unconcerned about our needs and problems. But this is so far from the truth.

Jeremiah discovers while observing the potter his hands never leave the clay. For if the potter were to remove his hands, the clay would spin out of control right off the wheel. So, the potter keeps his hands on the clay the entire time it spins on the wheel; gently, very firmly shaping and molding the clay into the vessel of his choosing. In the event that the clay becomes flawed in some way, even then the potter continues his work of shaping and molding. Although it may not seem like it at times, this is how God is with us, we are always in His hands.

This seems contrary to us in today's society. When things become broken or flawed in any way, we don't look to repair it, we toss it in the garbage can and replace it with something new and improved. But God is not like us, He does not throw us away when we are flawed or walk away from us when we make mistakes. No, He simply continues His work of shaping and molding to turn you into what He has in mind for you before you were even born.

There are many people who live under the shadow of despair because they believe that God has abandoned them. As a result of the inaccurate and false teaching of others, or through faulty thinking of their own, there are those who believe God to be the kind of God who would turn His back on His children. But this thinking is contrary to what Jesus said before His death on the cross. He said it was expedient for Him to return to the Father so that He could send the Comforter, the Holy Spirit, who would be with us always. He, Jesus said, would never leave nor forsake us.

Therefore, no matter what it looks like, no matter what you face in life, God never walks away. No matter what you go through God's plan still holds true for you. He will never take His hands off of you. When you are falling apart at the seams He is there shaping and molding in order to put you back together again. No matter how fast the wheels spins, you never have to fear God walking away leaving you to spin out of control.

For Reflection:

What is your thinking about God's presence in your life? Are you certain of His presence even in times of difficulty and uncertainty?

Day Six:
Journal Day

I praise you because I am fearfully and wonderfully made;
your works are wonderful,
I know that full well.
My frame was not hidden from you
when I was made in the secret place,
when I was woven together in the depths of the earth.

Psalm 139:14-15

God waits outside of the noise and busyness of our lives and days. When we intentionally listen, we enter into a more intimate relationship with Him. This can become one of the most meaningful aspects of your self-reflection, but it can also be the most challenging because it requires the willingness to be still. Spend some time today becoming quiet in His presence. There is no agenda; just give God your undivided attention until He speaks. Try to sit quietly for five minutes and just listen. When you have, write about your experience in your journal.

Day Seven:
Commitment Day

I praise you because I am fearfully and wonderfully made;

your works are wonderful,

I know that full well.

My frame was not hidden from you

when I was made in the secret place,

when I was woven together in the depths of the earth.

Psalm 139:14-15

Begin this next week with a commitment to spend time each day quietly listening for God's voice. Write your commitment on an index card that you carry with you as a constant reminder that what God says matters.

Part II

Becoming

Week Four:
A Created Persona

Scripture Reading:

So God created mankind in his own image,
in the image of God he created them;
male and female he created them.

Genesis 1:27

Day One:
The Masquerade of a Persona

So God created mankind in his own image,
in the image of God he created them;
male and female he created them.

Genesis 1:27

Many women go through their lives living as a figment of their own imagination. They become a new creature, someone other than who they really are, acceptable to those around them, a byproduct of the beliefs, wishes, and desires of others. In essence, who they really are becomes a prisoner to the persona they created, trapped behind the mask that they wear.

It is like the mask that one wears to a masquerade ball to disguise their identity from other attendees. Only the masquerade doesn't come to an end at the end of the night, it continues as a way of life as the created persona pretends to be the woman being held prisoner behind the mask.

It happens more often than you would think and with those whom you would not imagine. The reasons are varied. There are those who create personas to hide hurts, frustrations, and disappointments. There are those who create personas to make an impression or to hide from rejection. When negative situations as these occur, the authentic person whom she once shared so freely with the world around her, now hides behind a mask that becomes protection from the cruelty of other people's opinions.

Truly, wearing a mask could be caused by anything—cultural bias, racism, sexism, and even ageism. The mask even hides the shame of the traumas related to divorce, unwanted pregnancies, and financial devastation to name but a few. A persona created by the mask allows us to fit in with the status quo, allows us to move in new circles, and even think according to new patterns. The persona we create allows us to uphold family traditions and expectations, meet the standards of teachers, and even outshine our peers.

Above all else, a created persona conceals our flaws and allows us to present an image of the magnificence of all that we want the world to believe that we are. All at the cost of hiding the subtleties and uniqueness of who we really are.

This fact is, this is not what living is about at all. Living is about expressing one's self, one's thoughts, one's feelings, and one's gifts. Masquerading through life as someone you are not robs you of the joy that comes as a result of authentic expression and robs the world of the special gift that God gave you to share. Ultimately, masquerading through life robs God of His glory because the one He created is trapped, unable to do what she was meant to do. What a price to pay.

If you are going to be the woman that God intends for you to be then the real you must be set free from behind the mask.

For Reflection:

When you look in the mirror who do you see looking back at you? Is she a figment of your imagination? Is she someone you are pretending to be—a persona, a made-up person hiding the authentic you behind a mask?

Day Two:
The Mask: The Power of the Persona

So God created mankind in his own image,
in the image of God he created them;
male and female he created them.

Genesis 1:27

I once believed the universal concept of wearing masks began later in life, but I am now convinced that we are all conditioned to seek validation, approval, and acceptance from others by the time we enter school. This conditioning begins when we are babies as we learn to take our cues from our parents. Long before formal schooling begins, the paint strokes of their ideals, beliefs, and taboos are painted on the canvas of our lives.

As you continued to grow and attempt to define your own way, you did so against the backdrop of what you have been conditioned to believe. The games you played, the stories you listened to, the television programs you watched, the friends you played with, all reinforce the beliefs of your parents. As you did what you were told, you received validation, approval, and acceptance. These are all the things that make us happy little children.

As you matured and ventured off to explore new things, attended school with new friends, hung out on the playground, you soon discovered that there were some things and some people that met with the disapproval of your parents. This is where you learned the fine art of mask- wearing by either steering away from those things that caused censure or pretending not to be interested in those things, because the last thing you wanted to experience was the consequence of your parent's disapproval. So, you put on a mask pretending that your actions were reflective of who you really were or how you really felt.

In many ways the mask protects from the pain of rejection and the cruelty of other people's opinions. It hides the pain of disappointment that results from not being freely able to express who you really are. The mask also hides the hurt and frustrations of conforming to the desires of others. Yet, with all that it hides, the mask projects an image of a persona of what the person wearing the mask wants others to believe. In the case of a child it projects the notion, "I believe as you believe, dear parents."

When we begin to wear a mask, we often become stuck because the mask is difficult to remove and its effects are difficult to handle. We sometimes feel angry, tense, unhappy, and unfilled. We sometimes roam aimlessly about, chasing one thing after another, never fully completing or mastering anything. Each situation we face, good or bad, is a potential opportunity to add another mask or make the one we currently wear more elaborate. Rarely are we challenged to remove the validated, approved, or accepted masks of our childhood. But that is exactly what must be done.

It is time to stop reinforcing the created persona by dealing with the masks of your childhood so that the authentic you can come forth.

For Reflection:

What masks are you wearing that you acquired in childhood?

Day Three:

Masquerading by Rev. Angela T. Burden

So God created mankind in his own image,
in the image of God he created them;
male and female he created them.

Genesis 1:27

As women, it is sometimes difficult for us to accept that how we were made is wonderful. Scientific studies even suggest that we have difficulty accepting compliments. No one wants to be thought of as being cocky or conceited. So, we qualify a compliment by saying such things as, "Girl, you should have seen me yesterday," when a simple, "thank you" would do.

It is true, whether a woman is thought to have low self-esteem or not, that we seem to be wired for modesty. Women who exhibit confidence in how they look and what they have to offer the world are often shunned by other women. We say, "She thinks she's cute," or "She thinks she's all that." But, it's not her, it's us. We can't accept that someone is what we long to be: confident in themselves because we are lost in the masquerade.

What exactly is a masquerade? It is pretending to be someone you are not; disguising yourself. When you were a little girl playing dress-up, pretending to be a princess, and staging elaborate tea parties, you were considering all the possibilities of who you could be. To pretend to be someone you were not when you were young, exploring, and becoming was acceptable—it was a part of your evolution to self. But when you never take the mask off—forever pretending, never being your authentic self—you become a chameleon, changing with every situation. You have lost yourself in the masquerade.

Masquerading robs you of peace and robs the world of your presence. While masquerading you are never able to be at-ease. You know that who the world thinks you are isn't real: "going along to get along" becomes your mantra. Self-loathing sets into your heart. You begin to blend into the background to avoid the true expression of yourself. You lose your voice; you feel like you no longer matter. In the stress of it all, the wearing of the mask, and the constant pretending you feel frustrated. You begin to ask yourself: *how did I get here?*

So, how can we change science? How can we let go of negative feelings about ourselves? I'm glad you asked. We must be willing to take off the mask and accept who we are. We must show the world exactly who that woman with no filters and accept whatever reaction they may have, good or bad. Being authentic can be fear inducing; it could cost you some friends, some popularity, and even a career. But there is good news: you can overcome.

For Reflection:

When you consider the makeup of the human body, even the smallest part has significance and without it the function of the whole body would be altered. In the same way, without you, the real you, the world would is missing a critical member. What is the world missing from you?

Day Four:
The Masks We Wear

So God created mankind in his own image,
in the image of God he created them;
male and female he created them.

Genesis 1:27

We Wear the Mask
By Paul Laurence Dunbar

We wear the mask that grins and lies,
It hides our cheeks and shades our eyes,—
This debt we pay to human guile;
With torn and bleeding hearts we smile,
And mouth with myriad subtleties.

Why should the world be over-wise,
In counting all our tears and sighs?
Nay, let them only see us, while
We wear the mask.

We smile, but, O great Christ, our cries
To thee from tortured souls arise.
We sing, but oh the clay is vile
Beneath our feet, and long the mile;
But let the world dream otherwise,
We wear the mask!

In this poem written in the late 1800s, Paul Laurence Dunbar speaks to the way that African Americans dealt with the ugliness and harsh realities of racism. Unable to express their real thoughts and feelings, they wore masks that suggested that they were happy and content, while in reality the opposite was true. The mask helped to shield against the ingrained and unprovoked mistreatment from whites, but it also prevented them from expressing who they really were good, bad, or indifferent.

Just as men and women of Paul Laurence Dunbar's day were forced to hide any reaction that they had to life around them in fear of mistreatment or even death, many women live life attempting to appease others hiding behind a mask. In fact, I am almost certain, that all people can identify, in some way, with Dunbar's poem. For we have all, in some way, had to adjust our thinking, our reactions, or our lives to the will and opinions of others or our circumstances.

We have all been left out of the group or not chosen to participate on the team. Maybe you were told that you weren't good enough or that your dreams didn't make sense. Perhaps it was because of how you looked: you were too tall, too short, too skinny, too fat, too light, too dark, too this, or too that. Whatever the cause, the results are usually the same; we change to try to fit in. And unfortunately for some, after a time, pretending becomes a way of life.

No matter how you arrive to the point of wearing a mask, no matter how old you are or how young, hiding behind the mask is not the place you want to be. For hiding behind the mask impacts your ability to function authentically. Being behind the mask leads to unhealthy relationships and unhealthy behaviors, which leads to unproductive actions. You may look good, smell good, and even appear to be good but if you are hiding behind a mask, your view of the world around you becomes distorted.

For Reflection:

How do you identify with Dunbar's poem?

Day Five:
The High Price of the Masquerade

So God created mankind in his own image,
in the image of God he created them;
male and female he created them.

Genesis 1:27

I was visiting with one of my college girlfriends in her home after we had reconnected some years later at a church service. Sitting at her kitchen table watching our two young children play close by, we reminisced about our days as collegiates and shared the amazement of our lives as full-grown adults. We talked about our shared love of the Lord and our hopes for the future. It was a light and inspiring afternoon, but it took quite a different turn when her husband came home.

When he joined us in the kitchen, my friend introduced us and shared how we had met back in college through a mutual friend. He stood there listening intently and once she was done, he looked at me and nonchalantly asked, "So, are you Master Card or Visa?" I looked at him bewildered because I had no clue as to what he meant.

I thought it was a joke, but clearly it was not because he repeated the question, "Are you Master Card or Visa?" Seeing that I had no idea what he was talking about, he told me that a mutual friend that his wife and I shared back in college was plastic. "She is not real," he said. "She is phony, fake, plastic, like a credit card. If you were friends with her, then you must be plastic, too. So, which is it? Master Card or Visa?"

Needless to say, I was floored at his explanation of our friend. I had never heard anyone refer to someone as plastic before, fake yes, but plastic no. He went on to describe this mutual friend as someone who did not know who she was because she was so busy pretending to be something that she was not. That made her plastic like a credit card.

I am almost certain that our college friend would have been as offended to know that someone saw her as being plastic as I did at that moment. I am almost certain that she would say, "I'm not trying to be anyone but me." Though I had never considered myself to be anything but who I was—a mother, a wife, a daughter, and sister—it certainly got me thinking.

Who do I portray to the world? Who does the world see when they look at me? Do I portray that I am being who I am, or do I portray that I am trying to be someone that I am not? I didn't want to be thought of as being plastic; neither Master Card nor Visa. I want to be seen as being me; just plain ole me.

Unfortunately, we have no control over what conclusions the world draws about us. But what we do have control over is the authenticity of what we portray. The only way to ensure that is by dropping any façade, removing any masks, and embracing the woman you really are.

For Reflection:

Who does the world see
when they look at you?

Day Six:

So God created mankind in his own image,
in the image of God he created them;
male and female he created them.

Genesis 1:27

God speaks but He speaks to one behind the masks we wear; the one He created. The feelings to be more than you are, the desire to change are fueled by the promptings of God. The words God speaks are often distorted by the desires of the persona we have created. Perhaps your uncertainty about who you are and what your true purpose in life is meant to be is because you have concealed your true identity, creating a reflection, an illusion of who you imagine yourself to be.

Reflect on the scripture and your answers provided to the reflection questions and write your thoughts in your journal.

Day Seven:
Commitment Day

So God created mankind in his own image,
in the image of God he created them;
male and female he created them.

Genesis 1:27

Begin this next week making a commitment to become the woman that God created you to be. Write this commitment on an index card that you carry with you as a constant reminder of that commitment.

Week Five:
Make the Decision

Scripture Reading:

And a woman was there who had been subject to bleeding for twelve years, but no one could heal her. She came up behind him and touched the edge of his cloak, and immediately her bleeding stopped.

Luke 8:43-44

Day One:
Gotta Take Off the Mask

And a woman was there who had been subject to bleeding for twelve years, but no one could heal her. She came up behind him and touched the edge of his cloak, and immediately her bleeding stopped.

Luke 8:43-44

I cannot reiterate enough that who you really are, your authentic self is held captive, confined, until you take off the masks that you wear. Though you may accomplish much, you will never scratch the surface at being and doing all that you are capable of being and doing until you take off the masks. There will always be something gnawing at you; something that you cannot quite name or put your finger on; something that screams out from within. That something I tell you is actually a someone; your authentic self, desiring to be set free.

For years, I wore a mask to hide the insecurities that were the result of experiences from my childhood. The mask presented a distant and fearful persona, but deep within was the real me that longed for something more. As I began to seek to pursue the purpose of my life, I discovered how much my insecurities were hindering me from being the woman I believed I was meant to be. So, I decided it was time to drop the mask and reveal the woman who was hiding behind it.

If you are going to be the woman that you really want to be and the woman that God intends for you to be then you, too, are going to have to make the decision to free the real you from behind the mask. This is a process that can be quite daunting because it will require that you abandon the role that you played wearing the mask and move beyond the surface to delve into the depths of all that is being concealed behind the mask; those things that the mask was put in place to cover in the first place.

The thought of facing those insecurities may cause you a great deal of fear. Fear not only of having to deal with what is hiding there but the fear of exposing yourself to others, revealing that you really are someone other than who you have been portraying; someone with different feelings, a different personality, and different desires altogether. Those fears may be, at times, debilitating but you need to understand those fears can be and must be overcome.

You will never give birth to your God-given purpose fearing to reveal who you really are. Though God created you uniquely for something special, you will never walk in it until you first deal with the masks. Once this occurs, your journey to self-discovery can begin. Once the mask is gone you will be free to strengthen the real you who right now lies dormant. But imagine how you can and will blossom when you are set free. Won't you set yourself free today? Who knows where the journey may lead you.

For Reflection:

Have you ever thought about what you could do if you were totally free to pursue your true desires? The only thing that stands in your way is the mask that you are wearing today.

Day Two:

It's a Process by Rev. Veronica T. Lockett

And a woman was there who had been subject to bleeding for twelve years, but no one could heal her. She came up behind him and touched the edge of his cloak, and immediately her bleeding stopped.

Luke 8:43-44

It is not so much about "letting go" as it is "making the decision to let go." Letting go has been found to be the easy part. It is remembering what we have been holding on to and why we have allowed ourselves to hold on with death grips for so long that makes it hard to let go. Allowing ourselves to embrace making the decision can be most difficult and most challenging because so many factors play a significant role in letting go.

The things we often tell ourselves are: "It's too hard," or "I'm afraid." Well, aren't we all? Fear and difficulty have been the top competitors when it comes to making decisions, fear being number one. Other factors that hinder our process of making a decision include such things as procrastination and avoidance. We tend to avoid the whole process by putting it off in hopes that things will get better. We stall our process by waiting it out, all the while wishing for situations and people to turn a new leaf, but oftentimes they don't. Then we get caught in this rut called resentment and find ourselves mad at the world for continuing in this chaotic cycle that has drained us of what little hope we thought we had.

Dear friend, this is not the place we want to be. If you find yourself in this space, know that you don't have to stay there. You have what it takes to make the decision that will help you to become your best self. All of the resources you need are right there; however, sometimes we must be reminded of what we have.

The first thing to consider in making your decision to let go is that you have options. We spend so much time and energy fearing that once we let go there will be nothing to hold on to. However, this is not true. You get to decide what you will hold on to once you've let go of that thing or person that keeps you from being your best self. If you are deciding to let go of a painful past, consider embracing a pleasant future. If you are letting go of negative thoughts, consider embracing encouraging affirmations. Allow yourself the opportunity to choose, and don't beat yourself up if you haven't made your decision yet. Extend to yourself some grace and a little self-compassion.

Take a lesson from nature. She teaches us how to let go. The autumn/fall season is a wonderful way to experience nature in her process of letting go. The great thing to take notice of is that the leaves do not turn colors or release themselves from the tree overnight. *It's a process*! Your decision to let go should be the same.

For Reflection:

We often think of what we need to let go of, but what will you hold on to? Allow yourself to bask in nature and let her show you how to make your decision.

Day Three:
Moving Beyond Fear

And a woman was there who had been subject to bleeding for twelve years, but no one could heal her. She came up behind him and touched the edge of his cloak, and immediately her bleeding stopped.

Luke 8:43-44

Fear is a very powerful emotion that is often very debilitating. No matter how determined you may be to make a change and move in another direction, fear can stop you dead in your tracks. Fear can cause you to make decisions that run contrary to what you say you want while denying realities that are harmful and to your detriment. Fear can cause you to do things that jeopardize friendships and relationships while causing you to embrace situations that otherwise call for change. Left unattended, fear will cause you to call the abnormal normal and the normal abnormal. In essence, fear can and will change you into another person who is content living a life that you were never meant to live.

The Bible says God has not given us a spirit of fear but of power, love, and a sound mind. This means we have the ability to confront fear head on. Many times, we allow negative experiences from the past to continue affecting us indefinitely by denying that these things actually happened or by continually mulling over how different life would be if only the experience had not happened. This type of behavior is counterproductive and strips us of our ability to confront fear and move forward.

To confront fear, you must face what the mask hides, the experiences, the feelings, and the effect they have had on you. But, it is important that you understand that acknowledging negative experiences is not an admission of guilt, nor does it make what happened right in any way. But, what it does do is take the victimization out of it and gives you the power to overcome it.

Overcoming fear is a choice we all have to make individually. We must decide to reject fear by refusing to dwell on the what ifs or the shoulda, coulda, wouldas. I doubt that I am the only one who struggles with this, but it is almost second nature for me to come up with a scenario of what could possibly go wrong right off the top of my head. It seems, that for most people, it takes a great deal of effort not to go down that road called fear. It also seems that our minds are susceptible to deceptive thoughts which cause us to become overwhelmed by our own little made up scenarios. This, in turn, causes us to get caught up considering all the angles which further entangles us in the web of fear.

But all of that becomes obsolete when you remember the power that is yours over fear. You don't have to stay where you are or as you are. Freedom from the mask is yours if, indeed, you are ready to be free.

For Reflection:

Be honest with yourself. What fears do you have about taking off the masks you wear?

Day Four:

Establishing A New Attitude – Your Choice, Your Decision by Minister Teresa A. Sellars

And a woman was there who had been subject to bleeding for twelve years, but no one could heal her. She came up behind him and touched the edge of his cloak, and immediately her bleeding stopped.

Luke 8:43-44

Imagine the blank canvas of a painting as a representation of your life. The painting is blank at birth. The painting becomes a beautiful picture as our parents paint a portrait of a preferred and fruitful future. But as we grow older the painting becomes soiled with unwanted paint strokes. The painting becomes uglier, dirtier and distorted as we experience more and more of life and more unwanted paint strokes appear, applied by others and applied by ourselves. These unwanted paint strokes represent the negative, unwanted mistakes and experiences we encounter in life. This painting now has become an illustration of the development of our current attitude.

While we can't remove the paint strokes completely, or undo our past, we can choose to do one of two things: We can choose to just accept our painting as it is, with its unwanted paint strokes or we can choose to apply spiritual turpentine and establish a new attitude, a new perspective, a new way of looking at the painting of our lives to help us lessen the effects of our negative experiences.

Attitude – A settled way of thinking or feeling about someone or something, reflected in a person's behavior. In other words, a settled choice, **a conscious decision to <u>think</u> a certain way.**

We can't control our feelings or change the past, but we *can* choose our thoughts as we go forward into the future.

We "*be*," not become, but "*be*" what we think about. Who we are and how we behave is a direct reflection of our thoughts. Read Proverbs 23:7; Romans 12:2.

For Reflection:

Think about your own personal painting and its paint strokes (wanted or unwanted experiences) then choose to either accept your painting as it is with your current mindset, thoughts and behaviors or choose to change it by applying the spiritual turpentine of Scripture and prayer. YOUR CHOICE, YOUR DECISION.

Day Five:
Finding Meaning in the Experience

And a woman was there who had been subject to bleeding for twelve years, but no one could heal her. She came up behind him and touched the edge of his cloak, and immediately her bleeding stopped.

Luke 8:43-44

We are God's workmanship; the scripture says in Ephesians 2:10. The Greek word *poieo* which means a work or something made is translated here as workmanship[2]. It is the word from which we get our English word poem. Just as an author is very intentional about every word chosen to ensure that the poem being written conveys its purpose, God is just as intentional about us. Every experience we face is important in some way to our development. Everything, and I mean everything—every win, every loss, every gain, every setback, every failure, and every victory—has purpose and meaning for your life. If it occurred, it is important to who you are or to who you are becoming. Because God, is intentional about what He allows to occur in your life.

Wisdom doesn't come out of a book; wisdom is the result of learning from the experiences we face. It is the ability to think and act on what you learn in any given situation. Since God is very intentional about what He allows, it can be said that there is nothing random or haphazard about your life, your situation, or your circumstances. Every detail of your life, every experience that you have faced, are facing, or will face, is important to the divine purpose of your life.

We are who we are as a result of our experiences and none of those experiences can be tossed to the side or deemed unimportant. The very experiences that you resent, regret, or want to forget that they ever existed are the very ones that will shape you the most. You just have to find meaning in the experience.

While things such as being overly concerned about what others thought about me and their expectations played a critical role in me hiding behind a mask, it became much more important to me to move beyond those fears. I decided to be much more concerned about being the woman that God had created me to be than I was with what others thought or approved of. I confronted my fears one by one, reflecting on the experiences that I had faced and the situations that caused me to shrink back. In other words, I learned to make lemonade.

Just like you would make lemonade by adding sugar to sour lemons, I learned to make lemonade out of situations that were less than ideal. I learned that it isn't always the experience itself that is important, but what was important was what I made of it. So, I

[2] The Complete Word Study Dictionary: New Testament.

decided to take those less than ideal experiences and use them to propel me forward. It worked for me and it can work for you.

Any experience you may have had in the past that may have caused you pain, disappointment, or setbacks can be overcome just by learning to make lemonade. All you have to do is see beyond the experience and find meaning and, ultimately, you will find the strength to move beyond it.

For Reflection:

What negative experiences are you holding on to?

Day Six:
Journal Day

And a woman was there who had been subject to bleeding for twelve years, but no one could heal her. She came up behind him and touched the edge of his cloak, and immediately her bleeding stopped.

Luke 8:43-44

Luke 8:43-48 tells the story of a nameless woman who is described only as having an issue of blood. We aren't told how she developed this issue, only that she has been this way for twelve years. Twelve years is a long time to be sick. Twelve years is a long time to live with an issue, especially one that no one knows how to cure. For twelve years she suffered, spending money on medical treatments that only made her situation worse. She was stuck. Stuck in the isolation of her issue, because customs of the day prevented her from interacting with others. She was a social outcast; stuck.

Imagine being this woman. It really isn't all that difficult to imagine because most of us are or have been just like this woman except we aren't hiding out due to an illness that requires isolation. Something happened, and the result is us hiding behind a mask. Unfortunately, the longer we hide behind the mask the more difficult it is to come from behind it. Stuck pretending everything is okay, stuck pretending we have moved on. But the truth is we have not let go of whatever it was that happened. We are stuck in its grip, forced to live in isolation behind a mask of hurt and pain.

No matter the cause, stuck is not a good place to be. In fact, stuck is a very dangerous place to be because stuck seriously compromises your ability to function authentically. Thereby, impacting on your sense of happiness. What is your story? Write about it in your journal.

Day Seven:
Commitment Day

And a woman was there who had been subject to bleeding for twelve years, but no one could heal her. She came up behind him and touched the edge of his cloak, and immediately her bleeding stopped.

Luke 8:43-44

Make a commitment to do whatever it takes to become unstuck. Write this commitment on an index card that you carry with you as a constant reminder of your commitment.

Week Six:
Just Do It

Scripture Reading:

Therefore, if anyone is in Christ, the new creation has come: The old has gone, the new is here!

2 Corinthians 5:17

Day One:
Commitment Day

Therefore, if anyone is in Christ, the new creation has
come: The old has gone, the new is here!

2 Corinthians 5:17

With the weather finally looking like it was changing over for real, it was time to do
a little spring cleaning. Spring had officially sprung a few weeks back, but it remained
cold and dreary because of all the rain. With each passing day it was getting warmer and
it was time to do our annual spring cleaning.

Spring cleaning was no special time for my girls and I as they were growing up. It
was like drudgery. It started as I went from room to room in search of things we no
longer used. These were things that had accumulated around the house over the years that
once held some special value to us or something one of us just had to have when we saw
it. But with the passing years it had simply gotten lost with other sentimental "must have"
things in the basement, garage, closet, or the kitchen junk drawer.

It was never an easy task as I geared up each year for the frustration entering their
rooms carrying the dreaded black trash bags. Each year I said the same thing, "Anything
you have not played with, looked at, or touched since last year needs to go in one of these
bags." And each year they both stood there with straight faces declaring that nothing in
either of their rooms fit that description.

I tell you it was a major fight, neither one of them ever wanted to part with anything.
I had to resort to going into each of their rooms and asking, "Do you play with this?"
Their answer was always a resounding, "Yes ma'am!" Each thing that I picked up they
had just played with the other day—toys, dolls, games, things purchased on vacation,
items made in school. Everything, though it sat in the corner, in a drawer, under a bed,
was too important to let go of.

But one day, all that changed. I can't tell you what it was, except the passing of time,
but they each picked out a few things and said the rest could go. I was shocked! The same
stuff that was difficult to let go last year went this day in a black trash bag without second
thought.

What if it were possible to simply looked back over your life to observe the negative
and bad experiences that have been so difficult to let go of and then let them go? Would
you do it if it were possible? I tell you, not only is it possible, it is necessary for you to do
so in order to move forward.

For Reflection:

Holding on to things emotionally that no longer serve a purpose in helping you be your authentic self will do you more harm than good. The longer you rehearse it.

Day Two:

Overcoming Obstacles by Rev. Angela T. Burden

Therefore, if anyone is in Christ, the new creation has
come: The old has gone, the new is here!

2 Corinthians 5:17

Obstacles. Can you really overcome them? Yes, but you must be willing to do the work. An obstacle won't move itself. You must be willing to go around, over, under, or through whatever is blocking your progress.

When I was a young girl, I was a competitive runner. I could sprint to the finish line in record time because there was nothing hindering my forward progress. When hurdles were placed on the track, I could still make forward progress toward the finish line, but I had to exhort extra effort and strength to get over the hurdles. I still finished the race, I still had success, I was still a winner; but it required me to change the way I approached the race. The hurdles became a challenge.

The same can be said for life: nothing we face needs to go to waste. On this journey, both good and bad experiences help to shape us and help us in our becoming. But some obstacles frighten us. Being afraid and having to face obstacles is a normal part of life. The problem comes in when we are stifled by the fear.

Fear is an unpleasant emotion that breeds anxiety, and insecurity. Fear is a barrier, obstruction, hindrance, hurdle, and obstacle to you. But you don't have to become a slave to your fear—the shackles of fear hinder all progress. Replace your fear with faith. Believe that you possess all the qualities and strength needed to overcome whatever you may face.

To begin the process of overcoming fear, we must change the way we perceive the obstacle, renew our minds, and rethink the obstacle we face. Ask yourself: *Is it an obstacle or an opportunity?* An obstacle blocks your forward progress, but an opportunity helps you to grow. With an opportunity you push through it and press yourself to bring out the best of what's inside of you. In pushing, you gain strength, and, each time you do, you build more strength and experience for the next challenge.

To overcome obstacles, you must be willing to travel light; release the things of the past that weigh you down. Forgive yourself for past failures and mistakes—let it go. You may even need to release some people from your inner circle. To travel this journey, we call life, you will need people who can push you along and not weigh you down.

Take small steps and celebrate each victory. Encourage yourself through your journaling, meditating, and by doing things that give you pleasure.

For Reflection:

Be grateful for all obstacles in your life. You are more than able to conquer each one. The greater the obstacle, the greater the glory in overcoming it.

Day Three:
A Change In Thinking

Therefore, if anyone is in Christ, the new creation has
come: The old has gone, the new is here!

2 Corinthians 5:17

After a not so heated discussion the time had come to make a major change in my life. This, as you may know, is not an easy thing to do. Change, though sometimes necessary is often very difficult and also scary. But change is necessary in order to move forward. Things don't always work out as you plan. The perfect church doesn't always turn out to be so perfect. The respectful and compliant children are sometimes disrespectful and disobedient. The ideal job sometimes ends up being the worse decision of your life. But even still, change is difficult.

Sometimes we think that the change required is found in improving the circumstances of our lives. You know what I mean you just need things to work out in your favor – a better job, more money, people to just do the right thing. But I have found that sometimes the change that I have needed most was found right within me. It wasn't always people mistreating me. It wasn't always some strange set of circumstances that were happening to me. No, on a few rare occasions, ok more than a few, I had mistreated someone. I had said something that should not have been said or done something I should not have done. I had a bad attitude. I had unforgiveness in my heart. The truth is, the something that needed changing was me.

Once, after trying unsuccessfully to defend myself against the untrue words of a former friend, I realized that I would never be able to change the mind or perspective of someone who was bent on seeing it in a distorted way. So, I conceded defeat and declared my own personal victory. I decided to let it go. No more would I play the back and forth game of fighting a lie. I decided to simply move on without harboring hard feelings. I decided to do something different. I changed the way I thought about what was going on. I decided what others thought about me was absolutely none of my business. They were perfectly within their right to think how they wanted to. Just as I was well within my right to not care.

That was the beginning of a new season for me. Realizing that nothing that anyone said or thought could keep me from being the woman God created me to be empowered me to move forward. Perhaps you should empower yourself to move forward too.

For Reflection:

Some things are just not worth the fight anymore. Do you need to change your thoughts concerning a negative situation?

For Reflection:

Some things are just not worth the fight. Isn't it time to let it go?

Day Four:
Just Let Go

Therefore, if anyone is in Christ, the new creation has
come: The old has gone, the new is here!

2 Corinthians 5:17

We have all faced situations that are difficult to let go of. It doesn't matter whether the situation that left us financially crippled, emotionally scarred, or psychologically torn, the ability to just let go is difficult. Sometimes this inability to let go is the result of the guilt that has developed. Defined as the state of having done something wrong or a feeling of being blamed for something, guilt is not something that is always easy to resolve.

When a person has been found guilty of a crime in a court of law, they are said to be guilty. But, when that person has paid their debt to society for the wrong they have done, payment or restitution has been made. In the eyes of the law, that person is no longer guilty. For all practical purposes the fact of guilt is gone. But, the feeling of guilt does not always work that way.

The feeling of guilt attaches itself to its victim like a malignancy and it refuses to let go. Guilt distorts emotions, affects attitude, and impacts negatively on relationships with others. Left alone, it can leave a person feeling isolated and rejected, blaming themselves for things they did not necessarily do. The reality is our experiences, good and bad can all be used for our benefit. Each experience should be seen as a building block or stepping-stone that plays a role in preparing us for who we are becoming and what we will do in life. Therefore, instead of seeing negative experiences as your swan song or an opportunity to cry "woe is me," try seeing them as opportunities to help shape you into the woman you are meant to be.

Whatever has happened, happened and there is nothing you can do you to change that. The more time you spend trying to fix what happened, explain what happened, or prove what happened, the less time you have to make things happen. Furthermore, you can't control how people treat you. The only thing you can control is how you respond to it. If people mistreat you based on events from the past, let that be their problem, not yours. What they think is none of your business; your business is becoming the best you that you can be.

What happened in the past is not worth you spending any more time on. You have a life to live, a purpose to fulfill. Focus on the present, the here and now. Let the past be the past. You don't live there anymore; you live here, in the now. Forgive them and yourself and move on. You can't move on focused on the past.

For Reflection:

God is aware of everything that has occurred in your life and He still has a purpose and a plan for you. Just let it go and go for it.

Day Five:
Burn the Bridge

Therefore, if anyone is in Christ, the new creation has
come: The old has gone, the new is here!

2 Corinthians 5:17

There are moments in life when we simply must burn the bridges of our past. We won't find our future there. What God desires for our lives lies ahead of us. The past only serves as a reminder of what has been. Clinging tightly to it prevents us from embracing the present. Why hold on to what has been—the familiarity of days gone by, past failures, past successes, bad habits, old regrets, even your old way of life—when before you is a great potential of possibilities?

I know this all seems cliché-ish, but you can't move forward looking back. You can't be all that God created you to be fretting over what occurred or what didn't occur the last time you tried. If you want to be the woman God desires you to be, you must burn the bridges of your past so you can't go back.

You burn the bridges by acknowledging the hurt, the joy, or whatever it was that you are unable to let go of. Acknowledge how it made you feel, what it did for you, and how it either moved you forward or set you back. Doing this helps you to understand the significance of the experience. You can even do this with relationships that you are having difficulty letting go of. Be honest with yourself about the good and the bad. Being honest with yourself helps provides a solid foundation for which to build authenticity.

When I find it difficult to move forward from painful experiences, I often write about it in my journal. Writing about it helps me to get to the core of the pain. Once I can acknowledge the real source of pain it makes letting go and burning the bridge behind me possible. One time when I was finally ready to let go of a painful experience, I wrote an Ode to Pain…

That's it! I'm done! This here crap is for the birds.

I want better. I deserve better.

You don't deserve me, my time, or my attention.

As of this moment, right here I am letting it go.

So what I've clung to you for all of this time.

Now I recognize you for who you are – a taker.

You take but you give nothing in return.

You want your needs taken care of, but you could care less about mine.

To think I wasted all this time considering your feelings, at the expense of my own.

I tried being understanding; I tried being pastoral.
But later for all that. No more, I gotta go! I'm done.
So long, fair well, auf wiedersehen, goodbye!

What you seek is not behind you. When what you can be matters more than what you are holding on to you will let go and when you do burn the bridge and never look back.

For Reflection:

What are some bridges to the past you need to burn?

Day Six:
Journal Day

Therefore, if anyone is in Christ, the new creation has
come: The old has gone, the new is here!

2 Corinthians 5:17

Reflect on this week's scripture and your answers to the reflection questions then
respond to these questions in your journal. Be as descriptive as possible.

What experiences have I had?

What experience stands out the most?

What successes have I had?

Which one stands out the most?

What trials have I overcome?

Which one stands out the most?

How did I get where I am at this very moment?

Who Am I?

Day Seven:
Commitment Day

Therefore, if anyone is in Christ, the new creation has
come: The old has gone, the new is here!

2 Corinthians 5:17

This week has been one of looking over past experiences, both good and bad, in
order to find meaning in them. Make a commitment this week to burn the bridge that
leads back to the past by forgiving yourself and others. Write this commitment on an
index card that you carry with you as a constant reminder of your commitment.

Part III

Being

Week Seven:
Beginning Again

Therefore, I urge you, brothers and sisters, in view of God's mercy, to offer your bodies as a living sacrifice, holy and pleasing to God—this is your true and proper worship.

Romans 12:1

Day One:
Ready for Transformation

Therefore, I urge you, brothers and sisters, in view of God's mercy, to offer your bodies as a living sacrifice, holy and pleasing to God—this is your true and proper worship.

Romans 12:1

In the twelfth chapter of Romans, the Apostle Paul said, "be ye transformed by the renewing of your mind. "The word transform comes from the Greek word metamophoo, which means to be changed into another form. Paul was saying that the Christians in Rome needed to change. They needed to be transformed from their old ways, from their old selves, into who God desired for them to be.

Paul's word is true for us if we want to become our authentic selves in order to be who God desires for us to be. Transformation doesn't just happen on its own, it requires an acceptance of the process. In other words, we must authorize the change. That change is like the change that a caterpillar must go through in order to become a butterfly.

That fuzzy little caterpillar submits to the work of the cocoon for there is purpose in it. The caterpillar begins the process of spinning a cocoon around itself and once it is completely enclosed then the work of transformation begins. Inside of the cocoon, the caterpillar begins to make many difficult changes. It develops wings that slowly begin to grow. In time, these wings develop color and strength. The colors slowly become more and more vibrant and the wings become stronger and stronger until finally the work of the cocoon is done and that caterpillar begins to struggle to break free.

The struggle it endures strengthens it even more until one day, at just the right time, the fuzzy little caterpillar breaks forth from the cocoon, but when it does it is not the same as it was when the process began. No, a transformation has taken place. As it releases its wings from the cocoon, it is revealed that the fuzzy little caterpillar isn't so fuzzy anymore. In fact, it is no longer a caterpillar, but the time it has spent in the cocoon has transformed the fuzzy little caterpillar into a beautiful butterfly; vibrant in color, strong in ability, and now ready to fulfill its purpose as a butterfly.

It begins to flap its beautiful wings, it goes up a little, moving from petal to petal on a single flower. It goes up a little higher moving on to another flower until finally it soars across the sky fulfilling the purpose that God had in mind from the beginning for it to do.

When you submit to the transformation process that God has in store for you, your process won't be exactly like mine or like anyone else's. But it will be a process designed just for you. You will go from someone filled with regrets of things done and missed opportunities, one with no hope or sense of direction, one filled with fear, doubt and unbelief, one filled with insecurities and uncertainties to one who has been transformed into the one God purposed for you to be from the very beginning.

For Reflection:

In what ways are you like
that fuzzy little caterpillar?
Are you ready to be
transformed?

Day Two:

Developing and Maintaining a New Attitude by Minister Teresa A. Sellars

Therefore, I urge you, brothers and sisters, in view of God's mercy, to offer your bodies as a living sacrifice, holy and pleasing to God—this is your true and proper worship.

Romans 12:1

In an earlier devotional, *Establishing A New Attitude*, we discovered that an attitude is a conscious decision to think a certain way, positive or negative, but we do have a choice. How we think, speak or behave is a direct reflection of our thoughts. So, the first step in establishing a new attitude is to decide if you want to have a new attitude.

Looking at your life as it is right now, decide if your current thoughts, speech and behaviors accurately portray how you choose to think, speak and behave. If not, then the first step is to decide to change your perspective by deciding to establish a new attitude. How you think, speak and behave is a direct reflection of your current mindset.

The next step is to visualize the painting of your life. This painting as had several artists contribute to its composition, our parents, our experiences (good or bad), others and ourselves. As we look at our painting, we need to determine what we currently think about it. How does it make us feel? What changes would you like to see? We can't change the experiences of the past, but we can choose how we think about them as we move forward into our future.

After we have taken an honest assessment of our current mindset and have decided to establish a new attitude, we need to identify any negative thoughts we're carrying as a result of some of the unwanted paint strokes on our life's painting. We can't change or remove the experiences, but we can choose how we think about them.

The first step in changing how we think is to make the decision to let go of any negative thoughts about unwanted or unpleasant experiences, mistakes or failures. Choose to refuse to allow any negative experience to cause you to have negative thoughts about this situation. Choose to look for the lesson, learn from it and choose to leave it in the past. Choose to think of it from the perspective of, *this happened, I can't change it, but I can grow forward and not allow it to control my thoughts, my speech or my actions. I get to decide.* If the only positive thought you can come up with is: *I get to decide how I think about this, no one else has the authority to decide how I think but me.* That's a start in the right direction to take control of your thoughts, positively.

For Reflection:

Develop your own plan to overcome the negative effects and thoughts of the unwanted experiences in your life. You may choose to pray, read scripture, say affirmations, journal, or talk to a Sistah Girlfriend, or a combination of all of the above. The one thing you must remember is that deciding to establish a new attitude is only the beginning. Developing and maintaining a new attitude is an ongoing process, it's a journey.

Day Three:
Risky Business by Bernadette Adams

Therefore, I urge you, brothers and sisters, in view of God's mercy, to offer your bodies as a living sacrifice, holy and pleasing to God—this is your true and proper worship.

Romans 12:1

I was at a crossroads in my career, and I knew I had to make a change. "Change is good"; "Change is necessary for growth"; "if you always do the same thing, you'll always get the same results." Yup, I'd heard it all, and yet, there I was—stuck.

As I sat across the table from two young marketing professionals dressed in their power suits and speaking in succinct, crisp, marketing lingo, I realized that while I was the senior person in the room, I had the least amount of experience. Academically, I was on even ground. I had also been promoted several times at work. I was a rising star, or so I thought. I floated through City Hall with ease, conversing with political leaders and civil servants at every level. The weekly radio program I produced and hosted carried me into the homes, or cars, of people all over Baltimore every Sunday morning. Known to mayoral assistants and others as the point person on community events, if it was happening in the city, I knew about it. My Rolodex was a virtual Who's Who among successful players in politics, government, and the media.

How was it, then, that at that now prophetic meeting, I felt inadequate and out gunned? There I sat, gripped with fear and paralyzed with insecurity because I felt I didn't measure up. I had taken the "safe" road; went for the sure and safe city job, having convinced myself that as a working wife and mother, I couldn't afford the luxury of following a passion. But, as I sat through that meeting the lump in my throat got bigger and bigger and I couldn't breathe. I wanted to scream and walk out of the room, but I had no idea what to do or where to go. That's when faith kicked in and I heard myself saying "The Lord didn't bring me this far to leave me now."

I quit my job with no new one in sight. No prospects, no leads, no scheduled interviews. Heck, I hadn't even polished up my resume or written one cover letter. The truth of the matter was that I had exhausted my energy. My tank was empty, and there was nothing I could do for myself or by myself. Sometimes you must just be still. Thirty days later as I sat at my dining room table, the phone rang. Some time ago, during an interview for a job I declined to take, I spoke honestly about who I was. That interview led to the phone call. The very next day I was hired as a member of the Tim and Daphne Reid Show crew.

Growth is good. Change is good. But they both require taking risks. Risk taking is risky. You never know where it will lead you. If you're lucky, it will lead you to your authentic self.

For Reflection:

What risks are you willing to take to be your authentic self?

Day Four:

Realizing You Need Help
by Rev. Angie Smith

Therefore, I urge you, brothers and sisters, in view of God's mercy, to offer your bodies as a living sacrifice, holy and pleasing to God—this is your true and proper worship.

Romans 12:1

When discovering, becoming and being you, one thing you must remember is that sometimes you will need help. Yes, help. As you journey this life there are times when you will need someone to talk to and bounce ideas around with. You really can't do it all by yourself. Everyone needs somebody. This is not a sign of weakness but of strength. Realizing you have resources to assist you and using those resources at the appropriate time, shows that you are a woman of strength and power.

As women, we go through so much in our lives and usually we never spend time on ourselves, but instead focus on everyone around us. We will let ourselves go without believing that we have it all together and that we can do this thing without anyone else. We love trying to play Superwoman and this can lead of straight down a path of destruction.

Destruction is defined as an action or process of causing so much damage to something that it no longer exists or cannot be repaired. Like a puzzle, we spend so much time spreading ourselves out—a piece here and a piece there. But there comes a time when we need to collect the pieces of the puzzle and put you back together again by realizing we can't be everything to everybody. And yes, when it becomes overwhelming, you need to reach out.

First, identify your resources. Every woman needs resources to help her during those difficult times. Times when you feel like you are all alone, remember you are never alone. You have resources. Group your resources based on their level of experience and expertise, to know who you will need to reach out to depending upon the circumstance. And don't be afraid to seek professional help if needed.

When my dad died twenty-nine years ago, I went into a deep state of depression. I was trying to work and care for a child as a single parent. Everything around me was falling apart. My work was not getting done and my daughter kept asking what was wrong. This went on for about a month. My supervisor at work, realizing that I was not me said, "Hey, you have good insurance, why don't you consider going to talk to someone."

My first thought was, *no I'm a strong woman, I will get through this, I don't need to talk to a psychiatrist.* But the more I thought about it, the more I realized I needed help. I found a Christian counselor and my life began to change. From that day on, I concluded

that seeking help when needed doesn't make you weak, but strong. I was strong enough to not only get help, but strong enough to deal with the most important person in the world, me.

For Reflection:

Think about a time when you really needed help. Did you utilize every resource available to you? How can you make better use of your resources now?

Day Five:
Use the Right Resource
by Rev. Angie Smith

Therefore, I urge you, brothers and sisters, in view of God's mercy, to offer your bodies as a living sacrifice, holy and pleasing to God—this is your true and proper worship.

Romans 12:1

You will go through many seasons in your life. Some will be considered good and others not so good. Some seasons we face various obstacles that can sometimes seem unbearable. Don't give in, they are only there to help you grow. Other seasons, everything seems to be going great and things couldn't be better. The great seasons can be very tricky because when the season begins to shift, it can catch us off guard because we are not expecting things to go wrong.

I want to share with you to not dwell on the changing situation, the obstacle, but look at the season. In every season of our lives, there is a resource available to provide you help. During the good times, we forget about our resources because we don't need them. But they are still there. There are always others to help you, such as family and friends. Most importantly, don't forget about your source, Jesus Christ. He is always there to assist you, guide you and carry you through whatever you face in life.

As you begin to go through, look at your resources and find the best one for the season you are going through. I remember a time when I was in one of my greatest seasons. I had just given birth to a beautiful baby girl. At a glance, she appeared to be beautiful and healthy, growing day by day and then suddenly, here comes a change in seasons. My beautiful baby girl at two months old started having difficulty breathing. Upon examination by a doctor, it was discovered that the valves leading to and from her lungs had not completely developed. She was in the hospital for a few days and then over the next six months I had to monitor her breathing. Every night as we slept, I hooked her up to a heart monitor to make sure nothing happened. I was on edge the entire six months not knowing if one day would be her last. One day I was in a great season, the next day my season had changed. I needed help. I needed support. I needed someone who understood where I was and could help me to get through. This is when I realized my resource needed to change.

Not every season will lead you to the same resource. You will have highs and lows. Cherish the highs because they will help you through the lows. That same joy you had during the high times, will be needed to get you through the low times in your life. Again, don't focus on the problem; have joy as you travel through to the solution. Ask yourself, what can I gain for this season? Who can I lean on during this time? Once you answer these questions, you will begin to tackle the situation one step at a time.

For Reflection:

Are you utilizing the right resource for the season you are in today?

Day Six:

Therefore, I urge you, brothers and sisters, in view of God's mercy, to offer your bodies as a living sacrifice, holy and pleasing to God—this is your true and proper worship.

Romans 12:1

Reflect on this week's scripture and the answers you provided to the reflection questions from this week's readings. Then respond to these questions in your journal:

What makes me feel good about me?

Can you come up with ten virtues by which you choose to live by beginning today?

Day Seven:

Commitment Day

Therefore, I urge you, brothers and sisters, in view of God's mercy, to offer your bodies as a living sacrifice, holy and pleasing to God—this is your true and proper worship.

Romans 12:1

Make a commitment to live by your ten virtues for the next thirty days. Write this commitment on an index card that you carry with you as a constant reminder of your commitment.

Week Eight:
The Sistah Circle

Scripture Reading:

As iron sharpens iron,
so one person sharpens another.

Proverbs 27:17

Day One:
Sistah Girls

As iron sharpens iron,
so one person sharpens another.

Proverbs 27:17

For far too long women have bought into the notion that we have a difficult time getting along. Television supports this claim and unfortunately in many cases it has been found to be true. We are all aware of, have been involved in, or are in the midst of some negative interaction with another woman that went all the way left and we treated each other with anything but dignity and respect. But that does not have to be our narrative.

I believe that much of the difficulty we face with each other centers around the issue of insecurity—on both sides. One thinks the other thinks she is better, smarter, prettier, in some way. Yes, that's what I meant to say. Our insecurities cause us to think we know what the other is thinking and we act on those thoughts as if they were proven facts. When you think about it, I am sure you see how immature it really is.

I started Nu Season Nu Day Ministries, later renamed Journey Ministries, as a way to help women by empowering them to discover and fulfill their God given purposes while assisting in the development of healthy sistahly relationships. It was my belief then, as it still remains, that we can each do our own thing, be great at it, and be supportive of other women who are great at what they do.

In other words, my sistah girl making moves, being Boss, shining, and being fabulous, takes nothing away from me. I can also make moves, be Boss, shine, and be fabulous by doing my own thing. When I am being my best self, another woman being her best self does not intimidate me in the least bit. Instead it creates the possibility of a mutually supportive relationship between us. Women who I have developed this type of relationship with I call my "sistah" girls.

A "sistah" girl is a source of strength and in many ways your cheerleader. She has your back and is there when you need help, encouragement, or just a listening ear. A "sistah" girl is not in competition with you, she has her own dreams and purpose she is working to fulfill. She understands that sometimes she may need to sacrifice some of her valuable time and resources to help you get where you are going. Because she understands that if the shoe was on the other foot, you would do the same for her.

My "sistah" girls come from all walks of life. Some are married and some are single. Some go to church every Sunday and some hardly go at all. Some are in the limelight and some are hiding off stage behind the curtains. Some are successful and some are still trying to figure things out. But the thing that connects us to each other is the desire to see the other succeed. Do you have a friend who provides this kind of support? She, my friend, would be your "sistah girl."

For Reflection:

How would you define "sistah" girls?

Day Two:

A Sistah to the Rescue
by Bernadette Adams

As iron sharpens iron,
so one person sharpens another.

Proverbs 27:17

It was three a.m. and I couldn't keep my eyes open. Notes and flash cards were everywhere. They say nursing school is a "weed-out" process and I was starting to believe it. In undergrad, I could pull an "all-nighter" without blinking an eye literally, pun intended. I was older now though, a wife, a mother, and working three jobs. For a moment I wondered what had possessed me to think I could do all this now, NOW! Then I remembered the strong, unyielding adage of Maya Angelou, "Because you have the aptitude and no alternative." That was enough to jolt me back to reality and to quit my pity party. I had work to do, so best to just get to it.

I was never one to study in a group or with partners. That whole scenario kind of made me anxious so I usually avoided it. One time a classmate asked me to join her group because they were going to "pull an all-nighter." I chuckled at the memory because my response was "Honey, I sleep at 3404 [my home address] and a lot has to happen before I can even begin to think about study time." Another classmate said, "I don't know how you do it with a family." I replied, "I don't know how you do it without one." (It was always nice to find some clean underwear in the drawer when I knew I hadn't washed a load of clothes in weeks.)

As I sat daydreaming, I thought of my son. "Wait!" OMG, Andrew had a May Day program at school the next day and I had an exam I had been cramming for all night. I wasn't going to be there. A wave of shame, guilt, and sadness swept over me at the thought of my son being the only kid with no one there to cheer for him. No familiar face looking back at him from the audience. I was mortified.

Around 5:30 a.m. the birds were chirping outside my window. I couldn't wait to call my girlfriend. Sheila picked up the phone after a few rings and said, "Hey girl, what's up?" In rapid-fire succession I blurted out "Andrew has a program at school today and I can't…, I mean, I can't be there. I can't let my baby be the only kid to not have anybody there to clap for him. Please Sheil," as I liked to call her, "can you please call in sick from work today and go to Andrew's program for me? I know it's a lot to ask, but please, I'm desperate." Only your sistah-girl can hear the anxiety in your voice or feel the stress you feel from miles away and simply say "I got you!" No questions asked. Everyone needs a sistah-girl.

For Reflection:

"To the world you are one person, but to one person you may be the world."

- Dr. Seuss

Who are your sistah-girls?

Day Three:
Sistah Circle
by Rev. Veronica T. Lockett

As iron sharpens iron,
so one person sharpens another.

Proverbs 27:17

What comes to mind when you read the words "Sistah Circle"? Could it be a room full of loud talking women nagging and complaining about the woes of life, love, and family? Or a group of prestigious women you desire to be a part of going to book clubs, taking exotic trips, sitting in coffee shops sipping espressos with Greek letters stitched in colorful fabric from head to toe? Well, that's what some look for and it could be all of the above, however it may and may not be as supportive in meeting your particular need. A Sistah Circle may be comprised of one or two women expressing sincere care, concern, and accountability towards one another. For some, you may never go on any trips together, but every moment is valuable especially when there is a geographical distance that separates. In this case, every phone call is cherished as a precious investment.

When it comes to the Sistah Circle, matters of the heart are discussed. You tackle issues where self lies in a state of vulnerability, and these women are the ones to help you process and protect the work you've accomplished with yourself. These women know you, and only desire the best for you. There are women that walk through life thinking they don't need a Sistah Circle because of past toxic female relationships, or maybe the death of a Sistah friend left them feeling irreplaceable. Dear Friend, please don't be fooled. You need a Sistah friend, homegirl, ride-or-die, tell it like it is, all up in your business, in your life. Your Sistah Circle will help you and challenge you to be your best authentic self. Your Sistah(s) will be your support in aligning you with your God given purpose, nurturing you with love, while celebrating your womaness, and showing up for you when you have checked out of showing up for yourself. They will challenge you to do the work to become your very best.

The Sistah Circle is your HUB, this is the familiar place you return to when you need to be realigned with self, God, and purpose. Your Circle is the place where you (in the words of Ntozake Shange) "Find God in yourself and you love her FIERCELY." These women are the ones who will help to create a sacred space for you to be transparent and to do so without distraction or judgment. The Sistah Circle is *not* a cult or clique, but a few Godly women, chosen by God to be there to help you not walk this journey called life alone.

Dear Friend, if you are the one who desires this kind of life-giving kinship, it is our prayer that you'll open your heart to be what you desire for someone else. It's time for you to reach out as others reach toward you.

For Reflection:

How you can be the sacred space for another to be her best self?

Day Four:
Thank You to My Sistahs
by Rev. Gail Green

As iron sharpens iron,
so one person sharpens another.

Proverbs 27:17

Although we travel through life's journey with great expectations, there are seasons that you need someone who will walk alongside with you. Who do you turn to when the storms of life are raging? Ultimately, we know as believers God will never leave nor forsake you but when the road gets a little dark God sends you a sistah.

As I reflect on the pilgrimage, I recall an experience about ten years ago that serves today as a true testament of sistahs. The stock market had crashed, and the world was panicking over their losses. My faith in the Lord was strong and I believed that nothing could ever shake it. Well, my darkest hour came about six months later. The job that I loved and had been committed to was gone. Not because of the crash; I was let go.

I was determined that even a loss would not waver my faith. But the enemy stays on the prowl and my character and reputation were being attacked, too. Though I encouraged myself through this storm, the winds and the waves didn't stop. My finances were attacked. The car, the house, and the bills kept coming. It looked like the enemy was going to take me down, but God sent me an array of sistahs to walk with me.

These sistahs were not judgmental but, rather, sensitive to the faith that God was producing in me. There were older and wiser women who called, prayed, and sent cards of encouragement. There were middle aged women who said because I had faithfully been with them through their storms of grief, loss, and success, they would give to me in abundance. There were even the sistahs who wanted to take care of my enemies verbally. Seriously, you need sistahs who will have your back physically too.

Then there those when who used their resources to help. To my strong sistah who kept the hairdo fabulous without ever charging me a dime. God's blessing to the entrepreneurial sistahs who gave me opportunities to have employment. To my young sistahs who of course had no idea of my struggles, allowed me to continue to give of myself. For the Lord still requires us to continue our work even while going through. Last but not least, there were my natural sistahs, too, who have always been with me through the good and the bad times. To my Sistah girl Dr. Tamara E. Wilson, you challenge women to reach higher heights despite obstacles. For the words of encouragement that she gave just as I felt like fighting. You rendered these words, "Don't be bitter but be better."

My sistahs, when you feel like you're at the lowest points of your life, remember God is always there to help rebuild your strength by sending a sistah girl to help you trudge along the path. Thank you, my sistahs, for giving me the hope to continue my journey.

For Reflection:

Who are your sistah girls? Are there some sistah girls in your life that you need to express gratitude to? Why not do so today?

Day Five:

Break the Cycle

As iron sharpens iron,
so one person sharpens another.

Proverbs 27:17

I am sure that you have heard the statement, "I don't really deal with too many women; they just keep too much going on." We all have. Growing up with a bunch of girl cousins, I had little need for very many friends because we were always together and very close. Other girls always seemed to be at odds about something. They always seemed to work so hard to keep someone out of "the group." Someone was always "hating" on someone else for one thing or another.

I just want to keep it real. We all have done it. We have all compared ourselves to someone else and you know what comes after that, we pointed out all of her issues. When the reality is, we all have them. The college educated, well-dressed, six-figure-making, expensive-car-driving, living-in-the mansion, perfect kids, husband, and trained-dog-having sistah has just as many issues as the no-job-having, ninth-grade-education, bus-riding, four kid, four-baby-daddies-having sistah. We need to stop worrying about what's not right with or hating on what somebody else has and worry about being our best self.

We are all God's children and He loves each of us the same, with all of our issues. And what God expects is that we will embrace who we are and live in such a way that we accomplish His will for our lives while doing what we can to help other people. In other words, do you and be your sistah's keeper. Who else is going to look out for other women if it is not us? Go on I'll wait...

You know how it goes. We make far less than a man doing the same job. But, we have to be two times as good as he is in order to be considered comparable. The last thing we need to do is play cut-throat with other women. In my experience, women have been the greatest source of my struggle. There have been those who have been cheerleaders for me then out of nowhere they became the leader of the firing squad. There have been those who have been obstacles or have been the cause of obstacles to be placed in my way. Heck, there were even those who didn't like me simply because, "there is just something about her." Yes, it made me mad. Yes, I put them in the abyss and decided, "not to deal with women like that. They keep too much going on."

But, one day, God helped me to remember I what I had grown up hearing, "Two wrongs don't make a right." I decided to break the cycle. God began to show me that there were women out there who could be trusted, who were not interested in destroying others, and who also were concerned about being their best self. Over the years, those women have become the sistahgirls of my sistah circle.

I am so thankful to God for each of them many of whom are featured here in this book. My sistahgirls have taught me to see that my journey to discovering, becoming, and being me lead me to each of them, each on their own journey and what I found is the strength that I needed to be who I am, authentically.

For Reflection:

Reflect upon a time when perhaps you felt negatively about dealing with other women. How has your thinking been challenged or supported?

Day Six:

As iron sharpens iron,
so one person sharpens another.

Proverbs 27:17

 Reflect on this week's scripture and your answers to the reflection questions. In your journal write about how you might work to help break the cycle of women tearing each other down in the world around you.

Day Seven:
Commitment Day

As iron sharpens iron,
so one person sharpens another.

Proverbs 27:17

Make a commitment this week to break the cycle of tearing down other women by being a sistah. Write this commitment on an index card that you carry with you as a constant reminder of your commitment.

Week Nine:

Scripture Reading:

Brothers and sisters, I do not consider myself yet to have taken hold of it. But one thing I do: Forgetting what is behind and straining toward what is ahead, I press on toward the goal to win the prize for which God has called me heavenward in Christ Jesus.

Philippians 3:13-14

Day One:
Get the Eye of the Tiger

Brothers and sisters, I do not consider myself yet to
have taken hold of it. But one thing I do: Forgetting
what is behind and straining toward what is ahead, I
press on toward the goal to win the prize for which
God has called me heavenward in Christ Jesus.

Philippians 3:13-14

I once read somewhere when a tiger in the wild turns its ears so that the spot on the
back faces forward it is about to attack. At this point, whatever gets in its way will be
destroyed because it will not stop until it has devoured whatever it has set its eye on. This is
what is known as the eye of the tiger.

The Apostle Paul, the writer of this week's scripture, had the eye of the tiger. Paul
knew where he was headed, and his attention was focused in that direction. No matter what
was going on in his life he was focused on spreading the good news about Jesus. In every
letter he wrote, Paul preached Jesus Christ. If there was a problem with unity in the church,
Paul preached Jesus. If there was a need for clarity on any given subject, Paul preached
Jesus. Everything he did was done in an effort to fulfill what Jesus had given him to do.

Like Paul, you too, have to focus. If you are going to fulfill the purpose that God
planned for you, then you must have the eye of the tiger. Without it, you will end up
somewhere God didn't intend for you to be, doing what God didn't intended for you to do.
You do remember that God created you for a particular purpose, don't you? Doesn't that
just make you happy?

Of all the things that make me happy in life, and there are many, knowing that God
created me with purpose in mind, makes me the happiest. I mean having a husband,
children, family, and friends who love me makes me happy. Having a roof over my head
and food in the refrigerator, makes me happy. Having good health and being in my right
mind makes me happy, too. But when I consider that the Creator of the universe and
everything within considered me, before I was even in my mother's womb, by giving me a
specific purpose, that makes me truly happy.

It is tempting to worry about what lies ahead and what your actual purpose may be, but
doing so keeps you from focusing on what is right in front of you. Resist the temptation. In
my experience, God will usually only give you just enough information to help you move
in the direction He wants you to go in anyway. That's called walking by faith.

Stop worrying about what you don't know and what He has yet to reveal to you. Get
the eye of the tiger and focus on what He has given you. Everything you do ought to be
done in light of the fact that God has a purpose for you. When that becomes your focus
things like other people's opinions will no longer matter. Obstacles in your path, fear, others
or your own, will be fleeting, because like the tiger who turns its ears to reveal the spot—
you will be unstoppable.

For Reflection:

What has been your focus of your attention?

Day Two:
Take Time to Take Care of You

Brothers and sisters, I do not consider myself yet to
have taken hold of it. But one thing I do: Forgetting
what is behind and straining toward what is ahead, I
press on toward the goal to win the prize for which
God has called me heavenward in Christ Jesus.

Philippians 3:13-14

A few years ago, I found myself burning the candle at both ends by going non-stop day after day. Early in the morning, I worked on projects and answered email. During the day, I conducted and attended meetings. Late into the night, I prepared for services, developed ideas, and kept current by reading about new and developing trends. My weekends were filled with services and a flutter of activity. I felt quite productive as I checked items off my to-do lists. However, after several months at this pace, I was fatigued and extremely irritable. This led to distractibility and a plunge in productivity. It finally became clear that I needed to make some changes. Perhaps you can relate.

As women, we just don't know how to say no. We lead organizations, projects, and groups, large and small, we enjoy the exhilaration that comes with accomplishing our goals. This makes it is easy for us to get caught up, intoxicated with the effects of the results. However, with all of its rewards and feelings of fulfillment, discovering, becoming, and being you, if one is not careful, can really take its toll on you.

As you embrace this journey to being the authentic you, the best you that you can be, remember not to neglect the very important principle of self-care. Self-care begins with knowing when it is time to take a step back from everything else and rest. Even the Lord God rested. At the end of creating the heavens and the earth, and all that dwell therein, the sun, the stars, the vegetation, the oceans, the animals, and yes even humans, God stood back, looked at all He had made and said most confidently, "it is very good," and then He rested from His labor.

Resting, while seemingly a daunting task, can actually be quite fun and simple. I have incorporated "me-treats" into my schedule to address my self-care needs. These special moments often involve a day trip to the mountains or to the beach to relax and disconnect from the busyness of my life. But when those things are not possible, a quiet moment for a leisurely walk outside or time to indulge in my favorite past time, reading, can also do the trick. Disconnecting from our work, even for a short moment, allows us to be revived and rejuvenated, giving us a fresh perspective and a clearer sense of direction.

Whether you play a round of golf or enjoy a few days away, determine the things that allows you to disconnect and rest, then indulge in them frequently. Rest, because a lack of rest can lead to negative personal relationships and serious health challenges. These things block the flow of your creative juices and eventually allow burnout to settle in. Rest, for in doing so, you return with full vigor and strength, enabling you to be your best self.

For Reflection:

Remember, if the Almighty God, in His infinite wisdom, saw fit to rest at the end of creation, how much more so should we mere mortals?

Day Three:
Begin with the End in Mind

Brothers and sisters, I do not consider myself yet to have taken hold of it. But one thing I do: Forgetting what is behind and straining toward what is ahead, I press on toward the goal to win the prize for which God has called me heavenward in Christ Jesus.

Philippians 3:13-14

Productivity coaches begin their work with new clients by encouraging them to begin with the end in mind. The end, we believe, dictates the steps you need to take along the way in order to achieve the goals you set. Therefore, in order to chart the course, you need to begin with the end in mind. Those seeking to live their lives in a purposeful way for God would do well in doing the same.

Unfortunately, many of us have no idea what God would have us to do with our lives. But, I believe, knowing what to do is not so hard when you know what you have been given. What we have each been given are gifts. Some have been given quite a few while others may have only received one. But, we all, no matter who we are, have been given something by God to be used to fulfill the purpose of our lives. Our gifts are different and how we are express them are also different, but they all serve the same purpose to glorify God.

What gifts has God given to you? What natural talents were you born with? What things do you do well? What motivates you to get up each day? These things provide a piece of the puzzle in discovering God's specific purpose for you. They are indicators of what steps you need to take. It is the doing of these things that opens the door to recognizing the purpose for which God has for you.

In addition to determining what gifts you have, there are other ways of determining your purpose. Experiences, opportunities, and burdens that weigh heavy upon your heart can help you determine what you have been shaped to do. Look beyond the ordinary and see what has been placed right before you when you least expected it.

Mary was planning a wedding when she was chosen by God to carry the Messiah in her womb and deliver Him to the world. David was tending sheep when God chose him to be Israel's next king. Paul was prosecuting Christians when God called him to spread the gospel of Jesus Christ. Esther was busy being queen when God called her to save the Jews from extinction.

The life of the believer in Christ is a journey; a journey of fulfilling God's purpose. The journey for each of us is different. Nevertheless, each begins with one step followed by the next. Each step we take following the leadings of the Holy Spirit is a step in the right direction. When you live your life in this way, day to day, ultimately it will lead you to the place God will have you to be, doing the things He created you to do, the person He destined you to be.

For Reflection:

What gifts has God given to you?
What natural talents were you born with?
What things do you do well?
What motivates you to get up each day?

Day Four:
Run Your Race

Brothers and sisters, I do not consider myself yet to
have taken hold of it. But one thing I do: Forgetting
what is behind and straining toward what is ahead, I
press on toward the goal to win the prize for which
God has called me heavenward in Christ Jesus.

Philippians 3:13-14

Remembering our scripture text this week, Paul said he was pressing on toward the goal to win the prize. This paints the picture of an Olympic runner competing in a race running with all his might and as he approaches the finish line. Paul wasn't standing still, reflecting on what was behind him, nor was he concerned about other things that were vying for his attention. But he was running toward the goal. And he had no intention on stopping until he had reached it.

If you want to accomplish God's will for your life, I mean, if you really want to be who God wants you to be, then you have to do more than let go of some stuff, you gotta do more than focus on getting there, you gotta run towards it. Why step into the race, if you're not going to run? Aren't there enough people in the world sitting on the sidelines waiting for something to happen for them? If you want to fulfill God's purpose for you, you gotta run!

One of my favorite movie characters is Forrest Gump. Forrest was an intellectually challenged little boy and although the doctor said his back was as crooked as a politician, he had strong legs. In order to straighten his back, Forrest was required to wear leg braces on his legs. As children often do, they teased him and called him names. Everyone, that is, except his "best good friend", Jenny. Jenny and Forrest were like "peas and carrots."

One day as Forrest and Jenny were walking home from the school bus, some boys started throwing rocks at Forrest and one hit him smack in the middle of his forehead, knocking him to the ground. Helping him back to his feet, Jenny tells him, "Just run away Forrest!" He tries to run, but the braces make it difficult for him to do so. So, slowly, he hobbles along, trying his best to get out of harm's way, as Jenny calls out after him, "RUUN FORREST!" With the boys in hot pursuit on their bikes and blood dripping down from the cut on his head, Forrest continues to hobble from side to side, as Jenny calls out, "RUUUN, FORREST, RUUN!"

Suddenly, as the boys gets closer, the braces on Forrest's legs begin to fall apart. With steel and plastic flying Forrest starts running a little bit faster until the metal braces fall completely off of his legs, and Jenny yells, "RUUUN, FORREST, RUUN!" Forrest said, from that day on if he was going somewhere, HE WAS RUNNING!

My sistahs, God has a purpose for your life. He expects that you will with every fiber that is within you to run towards it.

For Reflection:

Imagine the impact on the world if each of us just ran, not any ole race, but the race, God gave each of us individually to run. What are you doing with all that God has placed on the inside of you. Life is short. Run your race. Live everyday pursuing your purpose and being the best you that you can be… RUNNNNNNN!

Day Five:
Just Be You by Rev. Gail Green

Brothers and sisters, I do not consider myself yet to have taken hold of it. But one thing I do: Forgetting what is behind and straining toward what is ahead, I press on toward the goal to win the prize for which God has called me heavenward in Christ Jesus.

Philippians 3:13-14

Life is a journey, designed uniquely for each of us to travel. Our destinies were created by God, not merely to just exist or live an unfulfilling or unrewarding life but we were created to leave our "mark" along the path. Inspiring, empowering and encouraging are just a few ways in which we make that mark. Included on this complex road, one passes through rough terrain and there is a need to find a support system to help get through the good as well as the bad times.

The Journey to Me ™ program was designed to empower women in all seasons of life to move forward in their journey while fulfilling her God-given purpose. A wonderful group of women came together just as they were. Passing by each month sharing their fears, brokenness, failures, and successes. The young offering hope and the older women extending their wisdom. An array of presenters teaching and admonishing women to maximize their potential. A true example of women given of themselves and therefore creating an atmosphere of positivity.

This interactive, self-discovering, empowering program sought to give women tools to enhance themselves and their journey through life. Preparations for this marvelous voyage began with the removing of the masks. The pursuit of fulfilling our God given purpose was the main thrust. Every woman should participate in the Journey to Me program. If that is not possible this companion book to the program is a viable alternative.

The task that lies ahead after discovering and becoming is to best who you are by continuing the race. Sistahs get on the mark and get ready to go "Just Being You." Run your course with perseverance despite forces and obstacles. Remember as you travel through difficult places, recognize that the enemy comes to steal, kill, and destroy. Do not fear. Fear robs you of your talents and relationships. As you move forward, tap into the very source that created you. God has given you exactly what you need to conquer them. It is your faith. Use your faith and watch it grow.

Approach each new day with faith. This allows you to fight against the wiles of the enemy who will try to use circumstances to try to destroy you and haters who will try to denounce the new you. Sistah, embrace your journey. Embrace the new you, flaws, fears, and all. Consider that God has said you are fearfully and wonderfully made. Accept the gifts, talents and the personality given to you. Cultivate them and use them for his glory. Remember it is God who unleashed the power within you to live out that extraordinary life. He has already equipped you for the destination.

For Reflection:

You have been gifted with the seeds of greatness. Embrace it and rise above any overcome that comes your way. Are you ready to embrace your greatness?

Day Six:
Journal Day

Brothers and sisters, I do not consider myself yet to have taken hold of it. But one thing I do: Forgetting what is behind and straining toward what is ahead, I press on toward the goal to win the prize for which God has called me heavenward in Christ Jesus.

Philippians 3:13-14

This poem was written by one of my Sistah girls. For years it has inspired me to be who I am, my very best self. In the spirit of the Sistah Circle, she is sharing it with you with the hope that it will also inspire you to continue discovering, becoming, and being the best you that you can be!

I'm Not tryin' to be
... anybody
...but me –

By Jacynth Marie Underwood

I like your hair, I like your style,
Your perfect walk, the way you smile,
But...I'm not trying to be...anybody but me.

I like your flair, your rings and things,
You hold it together, No matter what life brings,
But...I'm not trying to be...anybody but me.

Your fancy house, with all its trimming,
All that dazzle, My head is swimming,
But...I'm not trying to be...anybody but me.

Your wonderful husband, your doting children,
Your fluffy dog, There's nothing missing,

But…I'm not trying to be…anybody but me.

I love you friend, You've got it going on,
But when I lay down tonight, and down goes the sun,
But…I'm not trying to be…anybody but me.

For Reflection:

In what ways does this poem inspire you to be your best self?

Day Seven:
Commitment Day

Brothers and sisters, I do not consider myself yet to have taken hold of it. But one thing I do: Forgetting what is behind and straining toward what is ahead, I press on toward the goal to win the prize for which God has called me heavenward in Christ Jesus.

Philippians 3:13-14

Congratulations, you have completed the nine weeks of discovering, becoming, and being you. But don't stop here, continue the process of discovering, becoming, and being the woman God created you to be. I pray that you will embrace your journey—that unique journey that God lays right before you each moment so that you can authentically and without apology be your best self.

If you can commit to this write it on an index card and place it in a prominent place that you will see every day as a constant reminder of your commitment to be your best self.

Phenomenal Women

Wearing a floral dress with a sweater draped softly across her shoulders and her purse in the crook of her arm, the 110-year-old stepped onto the sidewalk in front of the courthouse. Squaring her shoulders, she shrugged off the family member who helped her and continued walking slowly down the walkway with the aid of her walking stick, stopping only a brief moment to look the sheriff in the eye who was determined to stop her. Then, slowly, she lowered her head and defiantly took a cool drink of water from the fountain marked "white only." Savoring the moment, looked at the sheriff, then just as boldly as she had come, she slowly walked back down the walkway.

This scene from the movie, *The Autobiography of Miss Jane Pittman*, was indelibly etched in my mind as a young girl. Though she was a fictitious character, Miss Jane, through the outstanding acting of Cicely Tyson, taught me that there are some things that you just must do.

This lesson was fueled sometime later by the Biblical understanding that we were all fearfully and wonderfully made by the all-powerful God, who, in some way that I don't claim to understand, molded into each of us everything we needed to do what He had prepared us to do.

Therefore, no matter who we are, we have, in some way, been uniquely prepared by God to do what no one else can do quite the same. Those who tap into the strengths, the gifts, the talents, and all the other things that God placed in them, discover something that others only dream of, and that is a sense of a God given purpose for their lives. And therein lies the making of a phenomenal woman.

But what makes a woman phenomenal?

Maya Angelou tells us that it is not in her size not in her looks. India.Arie says it is not her skin nor her hair. A phenomenal woman just can't be explained. She is a phenomenon. She just is. A phenomenal woman is just something you are, because you have found that niche, that thing that you were just meant to do in life. Phenomenal women are everywhere, you don't have to look far.

A search through the Bible will reveal some phenomenal women. There's Esther and Deborah, Abigail, and Huldah. There's Mary and Anna, Dorcas, Eunice and Lois. Some, though phenomenal, are not mentioned by name. They were the daughters of Zelophehad and the widow at Zaraphath. There was also the woman at the well and the Syro-Phoenician woman. They all in some way were faced with something that they could have ignored. But chose, in their own little way, to do what was necessary and because they did, their lives and the lives of others were impacted in a positive way.

That's what makes a woman phenomenal. She sees something that needs to be done and she steps up, she steps in, and changes the course of lives around her.

But that is not all. Phenomenal women are everywhere, you don't have to look far. Take a look back through history and there you will find some pretty well-known phenomenal women who stepped up when it was necessary to do.

There is Isabella Baumfree, who changed her name to Sojourner Truth. Though she was born into slavery, sold away from her parents at nine years old, with a herd full of sheep, sold and resold, suffered physical and sexual abuse, she made a decision to escape to her freedom with her infant daughter, leaving behind all the others, of which she said, "I did not run off for I thought that wicked, but I walked off, believing that to be all right."

She was phenomenal. Though she could not read nor write, she preached and lectured on the abolition of slavery and women's rights. In her most famous speech, given extemporaneously

she said: "...that little man in black there, he says women can't have as much rights as men, 'cause Christ wasn't a woman! Where did your Christ come from? From God and a woman! Man had nothing to do with Him. If the first woman God ever made was strong enough to turn the world upside down all alone, these women together ought to be able to turn it back, and get it right side up again!"[3]

There is so much more to her life and so many more phenomenal women who made a difference too, like Harriet Tubman and Daisy Bates, too. They are everywhere, phenomenal they are. Women who stepped up, you don't have to look far. There is Zora Neale Hurston, Toni Morrison, and Alice Walker; prolific writers who wrote out of their experiences and helped us to see the richness of our racial heritage. There is Mary Jane McLeod Bethune, Fanny Jackson Coppin, and Dr. Johnetta Cole; they stepped up to provide and improve on the quality of education for blacks who had long been denied. Thus, ensuring the chances of a brighter and more prosperous future. There is Madame CJ Walker, Camille Cosby, and Oprah, too. They made millions and unselfishly used their resources to help make a difference in the lives of others. There is Aretha and Gladys, and Roberta, too. MC Lyte, Queen Latifah, Salt and Peppa, too. Jill, Beyoncé, Fantasia, and Jennifer, too. There's my mom, and your mom, and every other mother, too. For without any of them, there would be no me and no you.

They raise doctors and lawyers and preachers too. They raise advocates and carpenters and athletes too. They raise mothers and wives, grandmothers too, who all step up and do their part to raise phenomenal girls. So, as you can see phenomenal women can be found in any arena

in any ole town. They're in technology and science, fashion and law. They're in religion, education, philosophy, and politics, too. No matter the arena, it's all still the same, a phenomenal woman rises to any challenge that's placed in her path. It has less to do with how much money she makes and more with how much of an impact that she makes. That is what makes her phenomenal.

<div align="center">

She transforms,
she changes lives,
she's gifted and smart.
She's productive, supportive, and strong.
She steps up,
she steps in,
she does more good than harm.

She does what she believes needs to be done.
She's not passive or aggressive,
she burns with passion and strength.
She'll overcome great odds to do what she needs to do.
She's not better than others,
has no perfect set of circumstances,
or a fast track to success.
She supports others,
she has no time for hating
because she understands

</div>

[3] Excerpt from "Ain't I a Woman?" by Sojourner Truth, from The Narrative of Sojourner Truth, 1875.

what needs to be done
is bigger than that.
So, just as Miss Jane,
stared the openly
racist system of the south
square in the eye
and defied its orders,
without any evidence of fear,
when we do
what God lays right in front of us to do
you and I also show our phe-nom-e-na-li-ty.

While you may not see,
what others can see,
you are, my sistahs phenomenal.
You are because
God made you that way.
Your life has purpose.
You will excel
because everything you need,
God has already given it to you.
It is already inside of you
to use with every opportunity He presents.
You don't have to seek out greatness,
it will find you.
All you have to do is
be yourself,
follow your passion,
and do what comes naturally.

She succeeds,
she excels
she is true to herself,
and no matter the cost,
she's willing to pay
because she considers it her obligation
to serve in this way.

Then you will know what Maya said was true,
You are phenomenal.
Phenomenally.
Phenomenal woman,
That's me.

About the Authors

Rev. Dr. Tamara E. Wilson is the pastor of *Nu Season Nu Day Ministry Church & Ministries* in Baltimore, Maryland. She has earned degrees from the University of Maryland College Park, St. Mary's Seminary and University, and the United Theological Seminary in Trotwood, Ohio. The founder of Journey Ministries, Inc., which focuses on empowering women to discover and embrace their authentic selves, Dr. Wilson is passionate about helping women achieve their God ordained best. In her spare time, she enjoys playing golf with her husband, spending time with her daughters, and simply hanging out with her Sistah girls.

Bernadette Adams, MPA, BSN, RN is a registered nurse and freelance event planner and writer in Baltimore, Maryland. She blends her love of helping people with beautifying the spaces they occupy to generate smiles every day.

Rev. Angela Burden, MA, BSN, RN is a native Baltimorean with degrees from the University of Maryland School of Nursing and St. Mary's Seminary &University. The first woman ordained at the New Metropolitan Church in Baltimore, she has a special heart for women's ministry, teaching Bible Studies and facilitating workshops for women.
Evangelist Gail Green is an Associate Minister at New Christian Memorial Church in Baltimore Maryland where for the past eighteen years she has served as the Women's Ministry leader equipping and empowering women to serve the Lord whole heartily. As a missionary, she travels abroad facilitating women's conferences and teaching and preaching the gospel.

Rev. Veronica T. Lockett is an educated and talented woman whose desire is to build the Kingdom of God one soul at a time through Christian Ministry, Education, and the Performing Arts. She is a strong supporter in helping women to honor their life journeys through self-reflection, meditation, and just plainly trusting the process
Minister Teresa Sellars is a graduate of Morgan State University. She has been a Bible Teacher for over thirty years and currently serves on the Teaching Staff and is an Associate Minister at the New Metropolitan Baptist Church in Baltimore, Maryland.

Rev. Angie Smith is the Senior Associate Minister and Director of the Women's Ministry at Perkins Square Baptist Church. She holds a Degree in Christian Counseling and Organizational Management from Columbia Union University in Takoma Park, Maryland, and a Pastoral Counseling certificate from Family Bible and Sarasota School of Counseling. Angie loves spending time with her grandchildren and traveling to the Caribbean.

Jacynth Underwood lives in Maryland. She is a mother of two and a grandmother. She is proud of her nursing career and excited about her God-given gifts of writing poetry, sayings of encouragement, and observations. In her spare time, Jacynth loves to design and sell her handcrafted jewelry.

Minister Teresa Sellars is a graduate of Morgan State University. She has been a Bible Teacher for over 30 years and currently serves on the Teaching Staff, and as an Associate Minister at the New Metropolitan Baptist Church, Baltimore, Maryland.

CPSIA information can be obtained
at www.ICGtesting.com
Printed in the USA
BVHW052310050920
588052BV00003B/14